HISTORIC MYSTERIES

of

WESTERN COLORADO

Case Files from the Western Investigations Team

David P. Bailey

THE
History
PRESS

Published by The History Press
Charleston, SC
www.historypress.com

Copyright © 2019 by David P. Bailey
All rights reserved

First published 2019

Manufactured in the United States

ISBN 9781467141376

Library of Congress Control Number: 2019932629

CONTENTS

ACKNOWLEDGEMENTS

I would like to thank everyone who has given their time and incredible expertise to the Western Investigations Team (WIT), especially Rick Dujay, PhD, our scientific coordinator, whose scientific expertise was invaluable to the team and who is now enjoying his retirement at his ranch. Former Museums of Western Colorado director Mike Perry has been there since the inception of the Western Investigations Team and has been an important team member. WIT archaeologists Phil Born and John Lindstrom made every WIT project a great teaching experience for the student interns.

Equally important is Colorado Mesa University president Tim Foster's support of the Western Investigations Team. He allowed us to use the campus scientific laboratories and consult with faculty scientists and provided our finest student interns. Many of these Colorado Mesa University student interns are now working in forensic science, research, law enforcement and as historians. Noted scientist Ken Kosanke, PhD, analyzed many of our artifacts and forensic material at the university.

Ron Bubar, owner of Grand Junction Subaru, and the Inge Foundation of Texas provided much-needed financial support to buy equipment, supplies and funding for exhibitions of our discoveries.

Erin Schmitz, curator of collections and archives at the museum's Loyd Files Research Library, has been invaluable in finding historical documents, scanning photographs and aiding with this book. Library volunteer Marie Tipping was wonderful at finding crucial historical documents and maps needed for our research. Museum collections assistant Vida Jaber scanned photographs from the WIT archives.

A special thank-you to Debbie Bailey, PhD, for her advice and editing of this book.

INTRODUCTION

The history of western Colorado is full of narratives from the many cultures that made this area their home. The Native Americans, explorers, settlers, town builders, cowboys and prospectors all added to our broad mosaic of history. western Colorado's history can be described as a pioneer patchwork quilt made of squares of very different fabrics and colors, each of which holds a memory. However, over time, the meaning of each square can fade from memory. What once was a succinct story can slowly turn into myths or legends or in time be simply forgotten. The aging patchwork quilt can lose its threadwork, and the squares that were firmly connected can come apart and leave their stories disconnected. The twelve stories in this book are those disconnected quilt squares rediscovered and, if possible, added back to the colorful patchwork that forms the unique history of western Colorado.

The first story in this book details one of Colorado's most famous murder mysteries: Alferd Packer, the "Colorado Cannibal." In 1874, Packer and five fellow prospectors became lost in the snowy San Juan Mountains of Colorado. Packer was accused of killing and eating his fellow travelers. Packer proclaimed his innocence and accused another prospector of the murders. This case was reexamined over one hundred years later by a team of modern academic and scientific experts in the hope of finding out what really happened to the five murdered prospectors. The multidiscipline team included experts in history, anthropology, archaeology, biology and forensic science. The team worked well together and decided to formalize

the partnership. This new team formed in 2005 and is called the Western Investigations Team. It is composed of experts from different disciplines whose mission is to investigate western Colorado mysteries, combining in-depth historical research with the latest scientific technology.

The state of Colorado is divided by a long stretch of mountains that runs north to south, known as the Continental Divide. The region west of the divide has historically been known by many names—the Pacific Slope, Sunset Slope, Western Slope and western Colorado. Thousands of years ago, Paleo-Indian hunter-gatherers lived in present-day western Colorado, followed by the Fremont Culture, which built pit houses and grew corn. Farther to the south, the Ancestral Puebloans built the incredible cliff dwellings of Mesa Verde. Historically, the region has also been part of many nations, including the Ute and Shoshone Indians, the Kingdom of Spain, Mexico and the United States, first as Colorado Territory and finally as the state of Colorado in 1876. The Western Investigations Team's mission is to solve some of western Colorado's enduring mysteries. Its investigations have covered a broad cross-section of western Colorado prehistory and history, including Uto-Aztecan history, the Spanish colonial period and the settlement era.

ALFERD PACKER

Solving One of the West's Great Murder Mysteries

In early 1874, six lost prospectors struggled against the unrelenting snow in Colorado's San Juan Mountains. In desperation, they found shelter in a deep ravine protected from the elements by a large stand of pine trees. The ragged men built a small fire on top of a rotten log. The prospectors, weak from hunger and numbing cold, sent one of their party out to search for the Los Pinos Indian Agency settlement. After a fruitless all-day search, the man followed his earlier tracks back to camp as darkness fell on the mountains. As he approached, a dark figure silhouetted against the fire rushed him with a raised hatchet. Startled, the man backed up, reached for his pistol and shot his assailant. The attacker, although slowed, reached his intended victim, and the man was forced to drop his pistol and fight for his life. The pistol, flung hastily aside, was lost in the deep snow...and from memory.

The mystery of what happened that day would begin to come to light 120 years later in the firearms storage room at the Museums of Western Colorado. In January 1994, the museum's curator of history, David Bailey, was inventorying the famous Audry Thrailkill Firearms Collection. Each artifact had to be photographed and checked for proper documentation, and a review had to be made of the object's provenance or associated history. The Thrailkill Firearms Collection has an amazing assortment of pistols, rifles, cannons, carbines and swords owned by famous and infamous figures of the Wild West. The collection varies from pristine weapons with extensive histories to firearms in terrible condition—known as relics—

because of decades of exposure to the weather. The relic firearms often have very little documented history.

Bailey was checking the documentation on an 1862 Colt Police Model pistol. The pistol was in poor condition—the grips were rotted off, the main spring was broken, and it still had .38-caliber cartridges in three of the five cylinders. The pistol had been issued as a .36-caliber cap-and-ball revolver in 1862 and was converted to fire .38-caliber rimfire cartridges in early 1870s. This small conversion pistol was inexpensive and was carried by miners and prospectors as a personal sidearm for protection while searching for gold and silver in the mountains. The pistol had little information other than a yellowed accession card that cryptically stated, "This gun found at the site where Alferd Packer killed and ate his companions." Bailey was very familiar with the Alferd Packer saga, as were most Colorado residents, who grew up on grisly tales of the "Colorado Killer and Cannibal." Bailey decided to do some in-depth research about Packer and find out if this odd little pistol was connected to Colorado's most notorious criminal. He began the long process of searching for genealogical records on Packer along with books and articles on the grisly murders and the trial transcripts from the case.

Packer was born to a Quaker family on November 21, 1842, in Allegheny County, Pennsylvania. Although he was born Alfred, he disliked the name and went by Alferd; he would often sign his name the same way. During his youth, Packer worked in a small printing shop. He left home and traveled west to seek work in Minnesota. In 1862, at the start of the Civil War, Packer enlisted in the Sixteenth Infantry and listed his occupation as shoemaker. He was discharged on December 29, 1862, from Fort Ontario, New York, due to epileptic seizures that left him unable to complete his duties. He reenlisted in the Iowa Cavalry and was also discharged for medical reasons. After his discharge, he found various jobs as a hunter, trapper and teamster before heading to Colorado Territory. Packer worked as a miner's helper in Georgetown, Colorado, in 1872. He then moved to Sandy, Utah, and worked at an ore smelter. In November 1873, Alferd Packer and a party of twenty-one prospectors left Bingham Canyon, Utah, to prospect for gold in Colorado Territory. Packer was chosen as the

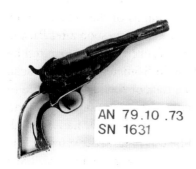

The 1862 Colt Police Model conversion pistol from the Audry Thrailkill Firearms Collection. *Museums of Western Colorado.*

expedition guide because he had previously been to Colorado. By January 21, 1874, the party had run out of food after losing supplies while crossing the Green River in Utah Territory. The group, near starvation and reduced to eating horse barley, was intercepted by the Ute chief Ouray and fifty warriors near present-day Delta, Colorado. Chief Ouray urged them to delay their expedition to avoid the dangerous early-spring weather in the mountains. Ouray offered to allow the men to stay at his encampment at Dry Fork until the snow melted in the mountain passes.

A few of the prospectors were eager to beat their competition to the goldfields of Colorado Territory and decided not to heed Ouray's warning. They made plans to travel to the U.S. government cattle camp (present-day Gunnison, Colorado) and then to the Los Pinos Indian Agency. Oliver D. Loutsenhizer and five other prospectors left in early February and nearly died from starvation and bitter cold before reaching the Gunnison cow camp. On February 9, 1874, Alferd Packer, Shannon Wilson Bell, James Humphrey, Frank "Reddy" Miller, George "California" Noon and Israel Swan also left against Chief Ouray's advice, and only one would survive the treacherous journey.

On April 16, 1874, Packer arrived at the Los Pinos Agency, forty miles west of Saguache, Colorado. The Indian agent, Charles Adams, was suspicious of Packer and asked what happened to his traveling companions. Adams questioned Packer, and he supposedly gave two confessions, the first that the group ate their companions one by one after they died of exposure. The first confession has never been found. In the second confession, Packer said he left to climb a nearby mountain and look for signs of a settlement. While he was gone, Shannon Bell killed the other men and started eating them. When Packer returned to camp, Bell attacked him with a hatchet, and Packer shot him and was forced to eat his dead companions or die. The party of prospectors that stayed with Chief Ouray arrived in town soon after Packer, and they began talk of lynching and hanging Packer. He was arrested by Charles Adams and moved to a makeshift jail in Saguache. The Saguache sheriff supposedly slipped Packer a key and a sack of food and told him to move on before he was lynched. The bodies of the eaten men were found in August 1874 and buried on the crest of a hill after Packer had escaped. Packer was on the run for eight years before he was finally rearrested in Fort Fetterman, Wyoming, and returned to Lake City, Colorado, for trial. Lake City did not exist at the time of the murders in the early spring of 1874, but the booming mining town, which incorporated in 1875, was just a few miles from the murder site.

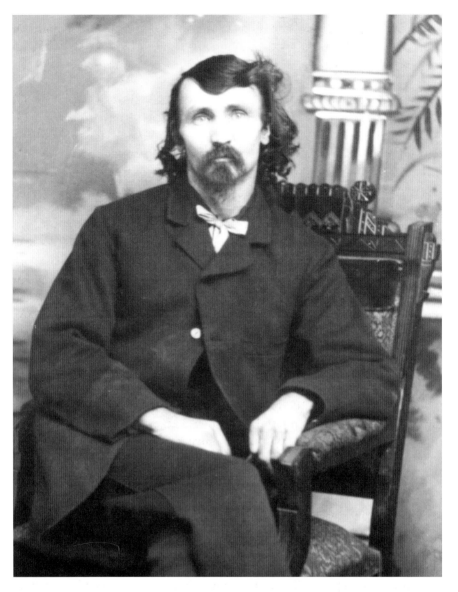

Studio photograph of Alferd Packer taken before his Lake City trial in 1882. *Museums of Western Colorado.*

Packer was tried in Lake City from April 6 to 13, 1883, and the prosecution had no real evidence to convict him but came up with the supposition that Packer led the men to a remote area to kill and rob them. The defense attorney at the trial never asked, if it was a case of robbery and murder, why Packer didn't just bury the bodies in the remote wilderness to cover up his crime. An article in the *Grand Junction News* dated April 21, 1883, felt the testimony left a lot of doubt about Packer's guilt and noted, "A first class criminal lawyer would have cleared him." Packer was sentenced to be hanged in Lake City on May 19, 1883. However, the case was thrown out on a legal technicality—Packer was charged under Colorado territorial law but tried under state law after Colorado's statehood in 1876. Alferd Packer was moved to the Gunnison jail in 1883, and his new trial lasted from August 2 to 5, 1886. He was found guilty of five counts of manslaughter and sentenced to forty years in prison. Packer served sixteen years and was eventually paroled. *Denver Post* reporter Leonel Ross O'Bryan campaigned for the release Packer due to the hardships he endured and his long prison sentence. Governor Charles S. Thomas relented under public pressure and granted him parole on January 10, 1901. One additional reason given for his release was that the murders occurred on the Ute reservation, and therefore he should have been tried in federal court, not state court.

Bailey reviewed the 1883 Alferd Packer trial transcripts and found no mention of Packer using a pistol to kill Bell. Packer referred to the weapon he used as a "gun" but gave no definitive description of the little Colt pistol in the museum collection. However, Bailey found an interesting story in the March 23, 1883 edition of Lake City's *Silver World* newspaper. The paper interviewed Preston Nutter, one of the original party of twenty-one prospectors who traveled with Packer from Utah. Nutter had remained with the main body of prospectors at Chief Ouray's camp until late spring and later was called upon to identify the bodies of the murdered prospectors. Nutter described the crime scene as follows: "None of the bodies showed any evidences [*sic*] of bullet wounds unless it might have been in one case, perhaps Bell's where a flat bone which might have been a piece of hip bone, with a bullet hole through it, lay near one of the bodies; also, a pocketbook with a bullet hole through it was found."

Bailey found the interview intriguing, because the museum's Colt pistol had three chambers loaded and two empty, which matched Nutter's story of only two shots being fired at the scene. If Preston Nutter had told the same story a few weeks later during Alferd Packer's trial in Lake City,

it would have corroborated Packer's version that he shot the real killer, Bell. However, Nutter completely changed his testimony. Packer's defense council, Aaron Heims, questioned Nutter:

> *Question: Do you recollect whether there was evidence of a gunshot wound there?*
>
> *Answer: There was a bone lying close to one of the bodies then. At one end it ran down to a sharp point four inches wide, run up at the other end, barely as thick as a man's wrist and about that long and a little hole through it, but the hole was round though it didn't [look] like a plain smooth shot.*
>
> *Question: Was it more like a gunshot wound than anything else?*
>
> *Answer: Yes sir.*
>
> *Question: Do you know which body that bone belonged to?*
>
> *Answer: I don't know which body.*
>
> *Question: You don't know if it was Bell's?*
>
> *Answer: No sir.*
>
> *Question: You didn't make an examination to see?*
>
> *Answer: No sir.*
>
> *Question: You don't know from what part of the body that bone came from?*
>
> *Answer: No sir.*

It was amazing to Bailey that Preston Nutter, a key witness at the crime scene, intentionally misled the jury about Bell's gunshot wound. It seemed that Nutter wanted to leave no doubt in the mind of the jury of Packer's guilt. However, Bailey realized the new information that two shots were fired at the crime and that the museum pistol had two empty chambers was still not enough to connect the gun to the crime scene.

Fortuitously, in April 1994, Phil Born, a volunteer archaeologist at the Museums of Western Colorado, happened to be cataloging artifacts and noticed David Bailey photographing the Colt conversion pistol. Born recalled seeing a photograph of the same pistol taken by his cousin Jim Harris many years ago. Bailey thought perhaps Phil's cousin could shed more light on the pistol's origin. On April 14, 1994, Bailey contacted Jim Harris in Texas and learned the unique history of the pistol and how the Museums of Western Colorado acquired it. Harris remembered that the pistol had been excavated in 1950 by Ernest Ronzio, a young Western State College historian/archaeologist. Ronzio was a student of C.T. Hurst, the father of Colorado archaeology. After the pistol was discovered at the Alferd Packer

Archaeologist and historian Ernest Ronzio excavated the Colt pistol at the Alferd Packer campsite. *Ronzio family photograph.*

murder site, it was brought to Jim Harris, a member of the Uncompahgre Archaeology Society, to be photographed and studied.

Bailey wanted more definitive proof that the Packer pistol was excavated by Western State College archaeologist and historian Ernest Ronzio. He noticed the Packer pistol had two different accession numbers on it. A museum accession number is an identification number attached to an artifact when it first arrives in a museum to identify and track it. This unique number allows researchers to find out information about the artifact by using that number to access the permanent artifact record. The first number was a Museums of Western Colorado number, black ink painted on a white background. The second number, in black ink painted on a yellow background, was the old accession numbering system used at the Western State College Museum in Gunnison, Colorado. Bailey was familiar with that museum's black-and-yellow accession numbering system from other objects transferred from Gunnison to the Museums of Western Colorado's collection. He contacted Pam French, a Western State College librarian, about the old accession number, 3926, which was on the pistol frame, and she found that number was logged into an early Western State College Museum registration book. The history attached to number 3926 revealed that noted historian and archaeologist Ernest Ronzio excavated the pistol at the Alferd Packer murder site in Lake City, Colorado, in 1950. Ronzio put the pistol on loan after it had been studied, and it was later acquired by famed firearms collector Audrey Thrailkill. He added the pistol to his collection, which was eventually acquired by the Museums of Western Colorado. This new information confirmed Jim Harris's story and gave more credence to the gun's involvement in the Packer case. Bailey knew that Colt Police Model conversion pistols were commonly used as prospector sidearms during the Packer period in the early 1870s, and it may have been discarded or lost by a different prospector or miner. Bailey needed more evidence to prove the pistol was used by Alferd Packer or someone else at the murder site.

The Museums of Western Colorado received a lot of media coverage and public interest in the Colt pistol after Bailey's discovery that archaeologist

Ernest Ronzio had excavated it at the Packer murder site in 1950. In April 1997, Bailey decided to put on an Alferd Packer exhibition at the museum coinciding with the ninetieth anniversary of Packer's death in 1907. In addition to the Colt pistol being put on display, Grand Junction resident Libby Beede and her family decided to loan a horsehair bridle made by Alferd Packer during his incarceration. Packer was a well-known prison craftsman who made horsehair bridles, watch fobs, elegant carved walking canes and Victorian dollhouses. The money from the sale of the Packer's craftwork was given to young inmates being released from prison to help their adjustment back into society. Beede also brought a very old and yellowed *Denver Post* dated December 21, 1906, with the front-page headline "Alfred Packer Is Sinking Fast." The article was written by Hugh O'Neill, the famous editor, author and lawyer who felt it was his duty to listen to Packer's deathbed confession. Bailey read the article with interest and found a startling revelation in his confession:

> *"When I got back Bell had killed those men," he muttered. "Killed them. They lay around the fire. Four dead men on their backs. He was a big red headed man and the strongest man in the party. He came running at me with a hatchet. He had the only hatchet in the camp. I could see he was mad. He made kind of a grating noise. I ran back. I had a revolver. When he got to the snowdrift I pulled my gun. He came on the run after me, and when I got to the deep snow, I wheeled around as quickly as I could and fired."*

Bailey had finally found evidence that Packer did use a pistol at the crime scene. It seemed there was mounting evidence that the museum's pistol was used by Alferd Packer to shoot the real killer, Shannon Bell. The pistol was excavated at the murder site by archaeologist Ernest Ronzio. The pistol's two empty chambers matched Preston Nutter's claim that two shots were fired at the crime scene. The case seemed even more conclusive with Packer's last confession that he used a pistol to shoot Bell.

On June 2, 1999, curator of history David Bailey and history museum cataloguer Jay Cayton took the Museums of Western Colorado's Alferd Packer historical memorabilia, including the Colt pistol found at the murder site, to the Hinsdale County Historical Society Museum in Lake City, Colorado. Hinsdale County historian Grant Houston and Bailey thought it would be nice to combine the two museums' Packer collections for an exhibit. The Hinsdale museum was only two miles from where the prospectors were murdered in 1874, and the exhibit generated considerable

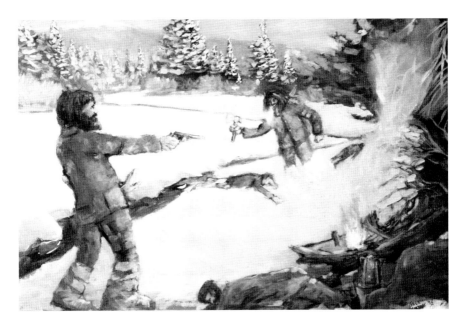

Artist Jack Murray's painting of Alferd Packer shooting Shannon Bell with the Colt pistol. *Museums of Western Colorado.*

interest in the community and with visitors. The exhibit, entitled *In Search of the Truth*, presented David Bailey's mounting evidence that Alferd Packer might have been innocent. Well-known Grand Junction artist Jack Murray created a series of paintings for Bailey portraying the events from the Packer case, including one that showed Packer firing the little Colt pistol at Bell in a last-ditch effort to save his own life. The Hinsdale County Historical Society Museum had a fascinating collection of Packer artifacts, including his prison shackles, a Victorian dollhouse he made in prison and pictures from the 1989 exhumation of the skeletons by James Starrs and a forensic team at the Packer site. The skeletons had been catalogued as A through E for scientific identification. Bailey noticed the skeleton marked A had a distinct round hole in the hip area; he assumed this must have been Shannon Bell.

Before the Lake City exhibit, Bailey made another interesting discovery concerning the bullet hole at the Colorado State Archives. In a file dealing with Packer's pardon applications was a letter written on July 25, 1899, by Oliver D. Loutsenhizer regarding his visit to the murder scene. Loutsenhizer had been the leader of the first party that left Ouray's camp and almost perished on their way to the Gunnison cow camp. Loutsenhizer stated, "I could only tell them by their clothes and

build it was them all right, there was no mistake. Three of them were killed as they lay round the camp fire, their heads chopped with an axe, but Bell the one he shot and the only one with shot mark, was about two rods from the fire with his head towards it."

This was the second confirmation that Bell had been shot, and Bailey reasoned that Bell's body was found away from the fire because he attacked Packer with the hatchet when Parker returned to the campsite. The 1989 forensic team initially believed the hole in the skeleton was from a bullet but then changed their minds and said it was an animal bite. Perhaps the group had not studied the historical records that indicated Bell had indeed been shot.

In October 2000, the Packer exhibition in Lake City ended, and Bailey went to pick up the museum artifacts. He was still curious about the bullet hole and asked Grant Houston, the Hinsdale County historian, if there was more information about skeleton A and the hole in the hip region. Houston showed him his excellent photographs of the skeletal remains taken in 1989, and the hole in skeleton A was very noticeable. He said the forensic team determined the bodies met a violent death and were cannibalized. Houston also mentioned that the Hinsdale County Historical Society had had kept the forensic samples from under the bodies. Bailey was quite surprised the samples had not been reinterred with the skeletons. He asked if he could borrow the forensic samples from skeleton A (Shannon Bell) for testing. He hoped there still would be gunshot residue in the samples to help prove Packer's story that he shot Bell at close range.

Bailey was given permission by the Hinsdale County Historical Society to test the samples collected during a 1989 examination of the Packer Party skeletons. He took the forensic sample from skeleton A (Shannon Bell) to Grand Junction to be tested by at a scientific laboratory. Bailey called Dr. Richard Dujay, director of the Electron Microscopy Lab at Mesa State College, and asked for his assistance with testing the forensic samples. Dujay said he would be glad to take on the project with his scientific colleagues and thought it would be a great forensic training for his student interns. Dujay knew that the challenge of finding gunshot residue after this long was quite daunting and told media representatives, "It's as if 127 years ago someone hit a baseball in the U.S. and now you're asking us to find it." Dujay and Dr. Ken Kosanke, an expert in gunpowder residue and pyrotechnics, along with student interns Chad Williams and Matt Marvin, began the process of analyzing bits of wool fabric, old buttons, debris and soil for traces of gunshot residue in the forensic samples.

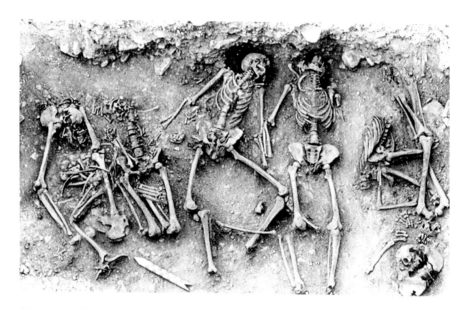

Photograph of the exhumation of the Packer party skeletons in 1989. The skeleton on the far left with the wooden directional arrow below it is Shannon Bell. Note the bullet hole in the hip region. *Grant Houston, Hinsdale County Historical Society.*

On February 10, 2001, Kosanke found a +50-micron lead fragment that was determined to be man-made because of its structure, size and composition. Dujay used an X-ray spectrograph to analyze the elemental makeup of the lead bullet fragment and found it was unusually pure. Dujay conducted further X-ray spectrograph comparisons of lead bullets from pre– and post–Civil War bullets to further validate the age of the fragment. He found it consistent with other bullets from the post–Civil War period. Dujay took a sample from one of the three bullets still in the Museums of Western Colorado's Colt conversion pistol found at the murder site. Dujay ran a side-by-side comparison of the Colt pistol bullet and compared it to the lead fragment found under Shannon Bell's body and came up with an exact match. Bailey had finally linked the pistol to the murder scene and had credible evidence that Alferd Packer was telling the truth about shooting the real killer, Shannon Bell.

Dujay then carried out a ballistic test using the same type of bullet used in the Packer pistol and black gunpowder to see if it would create the same type of impact on a bone. He used clay and elk hip bone to simulate Bell's hip region. He fired the bullet at a short distance to re-create Bell's attack on Alferd Packer. The results were astonishing! The test created the same round

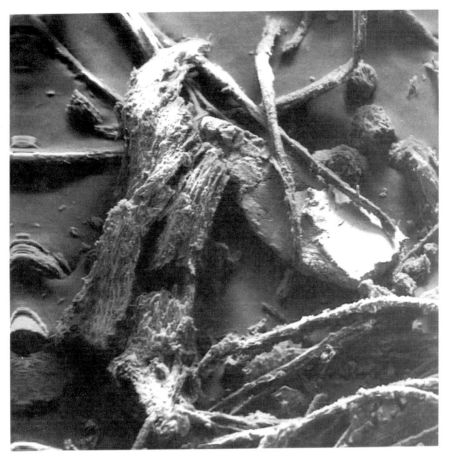

Ken Kosanke, PhD, found this lead bullet fragment in the forensic material under Shannon Bell's skeleton. *Museums of Western Colorado.*

hole that the 1989 forensic team misidentified as an animal bite. Dujay, who received his doctorate in wildlife biology, gave additional reasons why the bullet hole was not an animal bite. The bodies were still articulated and were not scattered by scavenging predators. There also was no evidence of bite marks on the other skeletons. Dujay concluded the hole was caused by a bullet hitting the bone. The Mesa State scientists and students continued their intensive laboratory analysis of the forensic material from under Bell's hip region, and on April 27, 2001, student intern Chad Williams discovered another bullet fragment.

On April 19–20, 2002, at the seventy-third annual meeting of the Colorado-Wyoming Academy of Science in Grand Junction, Colorado, Bailey and

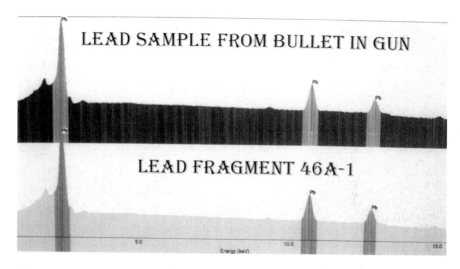

The lead sample from a bullet still in the Colt pistol and the lead fragment under Bell's skeleton were an identical match. *Museums of Western Colorado.*

Dujay presented their evidence that Packer was innocent and had shot the real killer, Shannon Bell. Bailey's scholarly presentation, "Reexamination of Forensic Documents Relating to the Alferd Packer Murder Case," detailed the historical research involved in solving Colorado's most famous cold case file. Rick Dujay, PhD, Ken Kosanke, PhD, and student interns Chad Williams and Matthew J. Marvin presented "Forensic Investigation of Cannibal Alferd Packer by Scanning Electron Microscopy/Energy Dispersive Spectroscopy." Conference attendees were fascinated by the combination of historical and scientific research used to solve the case.

After the discovery of the lead bullet fragment, the Museums of Western Colorado and Mesa State College were inundated with requests to do stories and documentaries on the Packer case from numerous print, television and film media outlets from all over the world. The publishers and producers were intrigued by the methods used to solved Colorado's most famous murder mystery. For the next several years, Dujay and Bailey were busy with interviews and shows concerning the Packer case.

In 2003, David Bailey was filming a documentary on the Packer case with a German producer, Miramedia Munich, at the burial site of the murder victims in Lake City. While Bailey was waiting for filming to begin, he looked down and noticed an unfired .38-caliber rimfire bullet in a small washed-out gully. Rick Dujay, who was also filming with Bailey, bagged the artifact and took it for analysis at the Center for Microscopy at Mesa

State College. The lead from the bullet found during the filming at the site matched earlier samples taken from the Packer gun and from underneath Shannon Bell's skeleton. This new discovery, while further tying the bullets to the murder locality, was also concerning to Bailey and Dujay. They felt other possible Packer artifacts might be uncovered and removed by souvenir hunters or visitors. They decided that a new archaeological expedition to the site was necessary to preserve any remaining artifacts in and around the Packer Party burial site. Additional objectives for the expedition included searching for the Packer Party's last campsite on the Lake Fork of the Gunnison River and Packer's second campsite, known as the Swanson site, near present-day Lake City.

During the first week of September 2004, the aptly named Alferd Packer Lost Camp Expedition headed to the Packer Party murder site. The group included five archaeologists: John Lindstrom, project archaeologist; Zebulon Miracle, assistant project archaeologist/historian; Grand River Institute archaeologists Carl Conner and Barbara Davenport; and Bureau of Land Management (BLM) archaeologist Julie Coleman. The Museums of Western Colorado expedition staff included museum director Mike Perry, curator of history David Bailey and curator of anthropology Kim Murray. Richard Dujay from Mesa State College also joined the expedition in Lake City. Prominent Grand Junction attorney Charles Reams served as the team's legal representative in case human remains were found at the archaeological sites and the State of Colorado needed notification. The team planned to do a visual inspection and metal detection survey on the high bluff where the victims were buried and at the base of the bluff on the edge of the Lake Fork of the Gunnison River. However, the steep cliff face between the two locations also had to be surveyed, and team member Mike McGinnis, a mountain-climbing specialist, would rappel down the cliff with a metal detector.

The archaeologists concentrated on the high bluff first and carefully flagged any metallic object for later study. They found the usual assortment of old beer can pull tabs, nails and bits of metal, but nothing definitively from the Packer Party camp of the early 1870s. On the cliff face, Mike McGinnis discovered some tin material with his metal detector. The team finds on the Lake Fork stream bank were astounding. Archaeologist John Lindstrom discovered the remains of Packer Party campfire on the edge of the Lake Fork of the Gunnison River. The site had charcoal remnants and a fragment of a rusted tinware cup. Packer stated in his testimony that Shannon Bell was cooking meat from one of the victims in a tin cup. Lindstrom also examined

Archaeologist John Lindstrom pointing to the place where he discovered Alferd Packer's campfire. *Museums of Western Colorado.*

two small dumbbell-shaped specimens that looked like human bone. After cannibalizing the victims, Packer moved downstream to a new campsite near present-day Lake City.

The team found no evidence at Packer's second campsite near Lake City, identified through early historical records by David Bailey. The camp, known as the Swanson site, was destroyed during the 1960s, when developers filled in the area with tons of gravel to create a trailer park.

When the expedition returned to Grand Junction, Rick Dujay tested the charcoal at the Mesa State Electron Microscopy Laboratory, and the results showed the charcoal had a high graphite content consistent with a maintained campfire. The tin cup fragment had a high-iron-content core consistent with nineteenth-century commercial tinware. What had been thought to be tiny bone fragments were examined and tested by museum anthropologist Kim Murray and Rick Dujay at Mesa State and found to be inorganic quartzite.

Engel Brothers Media, in conjunction with the History Channel, obtained the film rights to expedition and produced a two-hour documentary, *Cannibals*, that aired in 2005. The great success of the expedition and the collaboration between Mesa State College and the Museums of Western Colorado led

to the formation of a new organization, the Western Investigations Team (WIT), with curator David Bailey as the WIT director and Rick Dujay, PhD, as the WIT scientific coordinator. The Western Investigations Team would be composed of Museums of Western Colorado and Mesa State staff, scientists, archaeological consultants and student interns dedicated to solving Western mysteries through historical research and the use of the latest scientific technology.

On June 30, 2005, the newly formed Western Investigations Team conducted its first field expedition to the Alferd Packer murder site. The team—consisting of director Mike Perry, archaeologist John Lindstrom, WIT director David Bailey, WIT scientific coordinator Dr. Rick Dujay and WIT intern Tina Smith—investigated two new areas that had not been surveyed by the Lost Camp Expedition in 2004, with two new sophisticated metal detectors. Joining the expedition was Utah State University professor Bonnie Pitblado, PhD, and sixteen graduate and undergraduate archaeology students. The WIT explained the Packer project to the students and advised them where to search for artifacts. The group was broken into two teams that visually inspected previously unsearched areas and then swept the same area with the new detectors, which could pick up objects buried over fourteen inches down. One of the students found a period abalone button from a victim, and two other student groups using the detectors found a deeply buried lead bullet and musket ball. This last survey completed the search for artifacts at the Packer Party murder site. The bullets were examined by WIT archaeologist Phil Born, who is an expert in antique ammunition, and he determined that one of the bullets was .44 caliber, fired from a rifled barrel and tamped in a percussion-fired handgun. The second bullet was .32 caliber and fired from a small handgun. There was no way to tell who used them—perhaps Ute hunters or a later prospecting party traveling through the area.

After renewed public interest in the Packer case, Historic Littleton Inc., a nonprofit historical organization, decided to have a retrial of Alferd Packer in Littleton, Colorado. On September 14, 2002, Alferd Packer was put on trial at the old Littleton Town Hall. The characters in the trial were faithfully brought back to life by costumed interpreters. The main difference from the historic trial in Lake City was that David Bailey and Rick Dujay could present their new historical and forensic evidence that cast doubt on Packer's guilt. The duo presented the modern evidence on nineteenth-century-style placards, dressed in period clothing and with the proper melodramatic flair. The 265 people in the audience also served as the jury, and after a three-

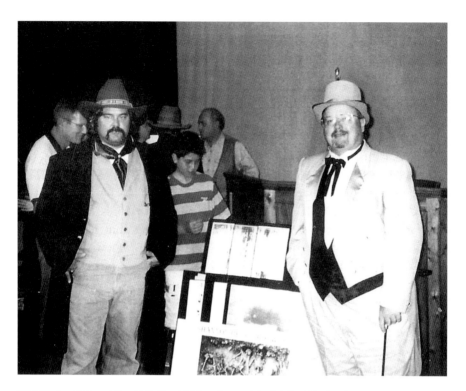

Rick Dujay (*left*) and David Bailey (*right*) at the retrial of Alferd Packer in Littleton, Colorado. *Museums of Western Colorado.*

hour trial, Alferd Packer was found innocent. Although it was a mock trial and not a court of law, it felt liberating to Bailey to finally see justice done. He remembered Packer's prophetic last words before he was taken to prison, quoted so well in Paul Gantt's book, *The Case of Alfred Packer: The Man Eater*:

> *In later years it will be cleared up for there has never been a case where a man has been sentenced unjustly that sooner or later it was not cleared up. I had one hope, and that was that sometime I would be able to hold up before the people of Colorado that I am not guilty of the murder of four men. I killed Bell. I admit it, and have done so all along: on the stand, in public, and in jail....As I said, before, the whole mystery will be cleared up sometime.*

THE LOST RELIC

In 1992, Museums of Western Colorado curator of history David Bailey met Keith and Anita Clark at an organizational meeting to form the Mesa County, Colorado chapter of the Old Spanish Trail Association. They told Bailey a fascinating story about a 1961 discovery of an old Spanish colonial relic during a hike in the Kannah Creek area, south of Grand Junction, Colorado. After their discovery, the Clarks sent the artifact to the Catholic diocese in Pueblo, Colorado, for scholarly study, and it was never returned. The Clarks had wondered about the fate of the relic for the last thirty-one years. They asked Bailey if he could assist them in locating the lost Spanish relic. Several weeks later, the Clarks gave Bailey a faded copy of a 1961 newspaper article that featured a grainy photograph of the relic. The article mentioned that it might have been from the exploration of two Spanish colonial priests who journeyed through western Colorado in 1776. It also mentioned that the relic was sent for examination to the Taylor Museum in Colorado Springs, Colorado, and later to the Hispanic Society of America and Metropolitan Museum of Art, both of which are in New York City.

Bailey contacted all these institutions seeking information on the missing relic. After the passage of thirty-one years, the museums uniformly answered that the curators were no longer employed at their museum, were retired or were deceased, and no records remained of their examination of the relic.

In 1995, Bailey wrote a museum article entitled "The Vision of Constantine" for the *Historian*, a regional western Colorado history newspaper. The article was a last-ditch attempt to find out information

Right: Keith and Anita Clark
with their family around 1961.
Museums of Western Colorado.

Below: *Southern Colorado Register*
article about the Clarks'
discovery. *Clark family photograph.*

about the relic for the Clark family and to discern if there were individuals with knowledge about it. Bailey was searching for someone who might know about its present location or news about additional archaeological discoveries that mentioned the object. The title of the article referred to the Roman emperor Constantine, whose engraved image was visible in a photograph of the relic in the 1961 newspaper story. The article discussed the importance of rediscovering such a rare Spanish colonial artifact and its possible contribution to western Colorado history. The article turned up no leads, and Bailey was back at the proverbial brick wall. He talked with Anita Clark again in 2004 in another attempt solve the disappearance of the relic.

In March 2004, he received a letter about their discovery and a more legible copy of the old newspaper article about their find from Anita Clark. The article detailed the Clarks' 1961 discovery of a strange relic in the Kannah Creek valley a few miles from Whitewater, Colorado. The article suggested that the relic was a fragment of a seventeenth-century processional cross from the Dominguez-Escalante Expedition, named for Fray Francisco Atanasio Dominguez and Fray Francisco Silvestre Veléz de Escalante, the two Catholic priests who traveled through present-day western Colorado in 1776. The expedition tried unsuccessfully to establish a route from Santa Fe, New Mexico, to Monterey, California, to connect with the West Coast Spanish communities and missions. The enclosed *Southern Colorado Register* article was entitled "Did Colorado's First Explorers Lose Bronze Relic?" It was dated September 1, 1961, and included a better-quality photograph of the strange metal relic with intricate designs. The article mentioned that photographs, and not the relic itself, were sent to several renowned museum experts, one of whom, Beatrice Gilman Proske, curator of sculpture at the Hispanic

Grainy newspaper photograph of the relic. *Museums of Western Colorado.*

28

Society of America in New York City, wrote, "It is indeed an interesting object, and the style is that of 17th century Spanish work." Proske mentioned that the scene on the top of the relic depicted the Vision of Constantine, noted in Bailey's 1995 article. Bailey found this fascinating, because the use of the first Christian emperor Constantine's vision in the design indicated it might be a Catholic relic from the Spanish colonial era. The photograph of the relic (which was thought to be bronze) was also sent to Stephen V. Grancsay, curator of arms and armor at the Metropolitan Museum of Art in New York City. He believed it may have been an "applied band" on a Catholic processional cross. The highly decorated band was placed on the face of a processional cross carried by priests to proclaim their Christian faith. The processional cross was a powerful symbol for Spanish colonial Catholic missionaries. Numerous Spanish colonial paintings and drawings depicted priests carrying the processional cross on their expeditions in the New World. Bailey was intrigued that the relic might be the only artifact ever found from the Dominguez-Escalante Expedition to western Colorado.

Bailey decided to do further research on Spanish colonial expeditions that explored the northern frontier, the area north of present-day New Mexico including western Colorado. He considered that the artifact might be from an unknown expedition that traveled through this area. The king of Spain, through the colonial government, required that Spanish explorers acquire an *entrada* (official permission) to travel to unexplored regions. Normally, these expeditions kept precise records to present to the king or his subordinates upon their return. However, many of the Spanish colonial government records were destroyed during the Pueblo Revolt in 1680. The Pueblo people revolted against the harsh Spanish rule and drove them out of Santa Fe, burning their buildings and records. There were also numerous illegal expeditions that operated without permission and secretly traded with the Ute Indians or prospected for gold and silver. The results of their expeditions were kept secret, and few records of these illegal activities survived unless they were arrested. The Spanish expedition histories were intriguing but gave no insight into the origin of the relic, and Bailey realized he needed to narrow his research. He decided to start with the theory that the relic was mysteriously left behind by Fray Francisco Atanasio Dominguez and Fray Francisco Silvestre Veléz de Escalante during their famous journey through present-day western Colorado in 1776.

In the *Southern Colorado Register* article, Grancsay believed the relic was a processional cross band, and the grainy photograph in the newspaper article showed the band was broken off at the bottom. Bailey read the English

"The Missionaries as They Came and Went." Illustration by Alexander Harmer for Zephyrin Engelhardt, *The San Juan Capistrano Mission* (Los Angeles, 1922), 20. *Wikimedia Commons.*

translation of Fray Francisco Silvestre Veléz de Escalante's diary of the 1776 expedition and found no mention of a processional cross or of one being destroyed during the trip. The destruction or damage to such an important religious symbol as the processional cross would certainly have been mentioned in their diary.

After examining the translated diary, Bailey spent months searching for associated letters, acquiring several rare and out-of-print Spanish colonial

history books for information that might shed light on the relic. He visited Spanish colonial research libraries in several states hoping to find new insight into the Dominguez-Escalante Expedition and their possible connection to the Kannah Creek relic.

The research included the biography of Fray Francisco Silvestre Veléz de Escalante. He was born in Trenceño, Spain, in 1750. At the age of seventeen, Escalante joined the Franciscan Order and traveled to Mexico. He was transferred to northern New Spain (present-day New Mexico) to conduct missionary work. There he taught Christian doctrine at the Zuñi mission. Escalante was an exceptional scholar and traveled extensively across the northern frontier.

Bailey thought there might be a mention of the processional cross and his proposed trip to Monterey in Escalante's personal letters. Many of the Spanish frontier missions had libraries, maps and documents, and he knew that Escalante reviewed the available histories on northern exploration before his trip. In a letter dated April 30, 1776, he mentioned receiving valuable information while smoking cigars with a Havasupai tribal member he met during his travels. The man used charcoal to draw a detailed map of the northern frontier on a saddle blanket. During their conversation, the man explained the terrain and the different tribal groups in the unexplored area north of Santa Fe. Escalante was still contemplating his proposed overland expedition from New Mexico to the Spanish settlements near Monterey. If a land route were established, it would increase the ability to keep in regular contact with Spanish coastal communities and missions in present-day California. After his conversation with the Havasupai man, Escalante decided it would be easier to travel through Ute country and take a northerly route to Monterey. The Ute Indians had signed a peace treaty with the Spanish colonial government in 1670, and he felt it would be safer to travel through their lands.

Bailey found no mention of a processional cross, and the letters mainly dealt with church business and the proposed trip in search of a route from Santa Fe, New Mexico, to Monterey, California. He decided his next course of action was to investigate where the relic was found in 1961. Possibly there was additional evidence or artifacts at the site to confirm the relic was part of the Dominguez-Escalante Expedition or from another unknown Spanish exploration.

In March 2004, Anita Clark accompanied Museums of Western Colorado director Mike Perry and curator of history David Bailey to the place where she found the relic. Bailey thought there was a possibility that

pieces of the broken processional cross might be found near the original 1961 discovery. He found it odd that such an important emblem of Spanish Christianity would have been desecrated. Perhaps the processional cross was damaged during the expedition, and there might be evidence of what happened at the site. Perry and Bailey brought along a metal detector to search for possible metallic artifacts that would shed light on how the relic may have ended up in western Colorado. Unfortunately, their visual search and metal detection in and around the original relic site yielded no evidence from the Spanish colonial period.

Anita Clark told them what happened to the relic after its discovery. The relic had been sent to Father John Sierra, a church historian residing at the Catholic diocese in Pueblo, Colorado, immediately after it was found. The relic never came back to the Clarks, and they learned that Father Sierra had died of a heart attack. The Clarks were not sure if the artifact had been sent to one of the eastern museums or lost when Father Sierra died.

In 2005, the Western Investigations Team (WIT) was created after the team's success on the Alferd Packer case. WIT director David Bailey and WIT scientific coordinator Rick Dujay decided to form another large expedition team and use GPS equipment to map out the area where the relic was found and conduct a detailed search by creating a grid for both visual and metal detection.

On June 22, 2006, the team returned to the Kannah Creek area of the 1961 relic discovery in search of other relic remnants or associated artifacts. On that same day, the *Denver Post* ran a front-page story about the expedition and featured a picture of the artifact found forty-five years earlier by the Clark family. The next day, Bailey, Dujay and WIT volunteers conducted the first official survey of the area. Mesa County surveyor Keith Corey and his crew brought a GPS Trimble unit to map the search area. The Trimble unit utilizes an artificial constellation of twenty-four satellites that gives the user exact coordinates down to a square meter. This enabled the search team to record artifact locations and their proximity to related artifacts. The surveyors created a large grid area—96 feet by 132 feet—with wooden stakes and recorded the grid coordinates with the Trimble unit. At the center of the grid was the location of the relic discovery in 1961. The team broke up into small groups and conducted a search with metal detectors and by visual inspection of each corridor within the grid. Archaeologists Brian O'Neil and Phil Born assisted with the visual search in the southern section of the grid. Museums of Western Colorado anthropologist Kim Murray and curator Zeb Miracle also assisted with the visual survey in the southern area

of the grid. The WIT crew found materials related to nineteenth-century occupation but no other artifacts associated with the relic. However, the archaeologists did record an unusual rectangular stacked-stone structure in the northern grid that would later become a very significant addition to the unique history of the Kannah Creek valley.

A few days later, Bailey received a call from Cara DeGette, an editor with the *Colorado Springs Independent*. He learned that ninety-four-year-old Monsignor Howard Delaney of Pueblo had seen the picture of the artifact in the *Denver Post* and realized that he had the relic in his possession. Forty-five years earlier, when Father John Sierra had been sent to Argentina on an eight-year mission, he had entrusted the relic to his friend Monsignor Delaney for safekeeping. It turns out that Father Sierra did not die but was preparing to celebrate his ninetieth birthday party in Maryland! The lost relic was kept in a greeting-card box in Delaney's file cabinet for forty-five years and forgotten about until the newspaper story rekindled his memory.

Mike Perry, Rick Dujay and David Bailey took a fifteen-hour round-trip drive to pick up the relic in Pueblo and talk to Monsignor Delaney. The relic was brought back for study at the Mesa State Electron Microscopy

In 2006, the WIT searched for relic remnants in the Kannah Creek valley. *Museums of Western Colorado.*

Laboratory and at the Museum of the West. The Clark family was pleased the relic had been found after forty-five years, and Anita Clark graciously donated it to the museum.

Rick Dujay tested the artifact at his lab and found the object was cast out of pure copper. The fine quality of this copper casting was not typical of the Spanish colonial period, which normally utilized iron and bronze for decorative metal designs. With the real artifact in hand, Bailey was able to discern that the symbols on the relic were not of Spanish origin but were decorative elements from a Masonic Knights Templar sword scabbard. Bailey then studied the many different patented designs for Masonic sword scabbards and determined the design was from the mid-nineteenth century. He found the symbolism of the relic related to the teaching of the Freemasons. The most prominent symbols on the relic included an inverted triangle in the sun, a reclining Emperor Constantine looking at the cross in the sun, a coat of arms and a cross within a crown. These symbols represent the Knights Templar degree in York Rite Masonry. The inverted equilateral triangle that appears in the sun on the top left corner of the relic is the Masonic symbol of the Grand Architect of the Universe (God) and is considered one of the most important Masonic symbols. The top section of the relic depicts Emperor Constantine staring at the cross in the sun. According to legend, the pagan Roman emperor Constantine had a prophetic vision. In AD 312, Constantine was preparing

Monsignor Delaney showing the filing cabinet where he kept the relic for forty-five years. *Museums of Western Colorado.*

for battle against his rival Maxentius. Before the battle, Constantine looked at the sun and saw a vision, the sign of the cross and the words *In hoc signos vinces* ("In this sign you will conquer"). Constantine painted the cross on his war banners and soldiers' shields and defeated his enemy at the Battle of Milvian Bridge. Constantine became the first Christian emperor of Rome. The Masonic Knights Templar adopted *In hoc signos vinces* as their motto and commitment to God. The center section of the relic depicted the body armor (corselet) and battle axes (halberds) representing the offensive and defensive weapons of a knight, in this case the Knights Templar Order of Freemasonry. The cross and crown symbol at the bottom represented the reward in heaven (the crown) coming after the trials of earthy life (the cross). It was adopted as the symbol of the Masonic Knights Templar and is on their uniforms and memorabilia.

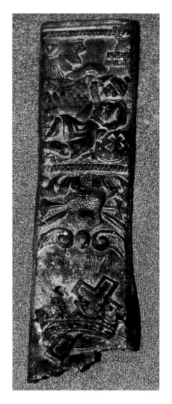

The relic after its return to the Museums of Western Colorado. *Museums of Western Colorado.*

The Masonic relic dated to the mid-nineteenth century and was created before the formation of the Freemasons lodge in Mesa County, Colorado. On June 18, 1883, fourteen master Masons of Mesa County were given a dispensation to hold their ceremonies under the name Mesa Lodge No. 55. Early Freemasons and pioneers of Grand Junction included R.D. Mobley, J. Clayton Nichols and Thomas B. Crawford, nephew of Grand Junction founder George W. Crawford. Bailey still wondered how a broken mid-nineteenth-century Masonic relic ended up in the remote Kannah Creek valley before the settlement era. The Western Investigations Team's first major historical mystery had been solved with the return of the lost relic and its true history uncovered.

THE REDOUBT SITE

On November 11, 2006, WIT director David Bailey and scientific coordinator Rick Dujay started the investigation of the rectangular stacked-stone structure discovered during the lost relic survey in the Kannah Creek valley. They dug around and slightly below the boulders and found that the stones on top were part of a wall that tilted in nearly forty degrees. When they uncovered all four sides, it took on the appearance of a truncated pyramid (a four-sided pyramid with the top cut off). There was no evidence of any artifacts in or around the stone structure.

After the return of the Masonic relic, David Bailey had completed an extensive amount of research on the history of Freemasonry, and he remembered that the unfinished pyramid was a major symbol used by the Masons. Perhaps the Knights Templar sword scabbard relic found nearby was connected to the pyramid site. It is well known that the early Freemasons who traveled out West often met at outside locations when no lodge was available. Freemasons had an ancient tradition of meeting near the highest hill and lowest valley to secure privacy. The stone structure met the Masonic criteria for the lowest valley, since Kannah Creek was considerably lower than the desert floor. The outdoor Masonic sites also required nearby high hills to post lookouts to ensure privacy during ceremonies. The stone structure was encircled with hills and tall bluffs. The site was near the Spanish and Ute trails used frequently by early mountain men, like Kit Carson, a well-known Freemason. Perhaps the stone structure was a remnant of an outdoor Masonic site. The WIT crew decided to come back later to complete a more thorough investigation of the site.

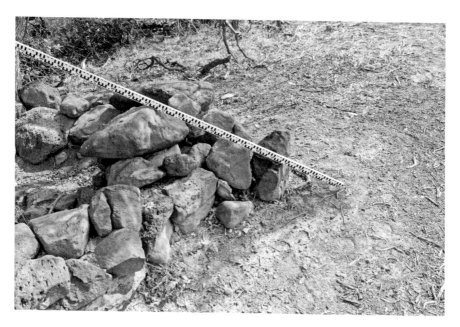

The rectangular stacked-stone structure's mysterious tilted walls. *Museums of Western Colorado.*

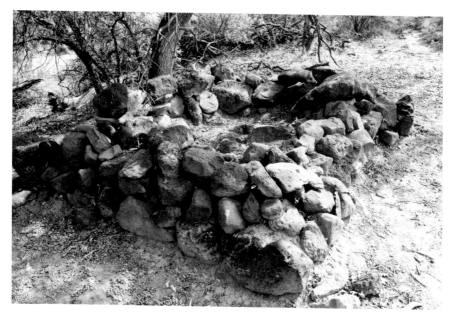

The uncovered stone structure took on the appearance of a truncated pyramid. *Museums of Western Colorado.*

On September 21, 2007, Dujay and Bailey cleared debris and foliage from the area around the truncated stone pyramid in preparation for the excavation of the site. They also took extensive photographs to document the site. The next day, David Bailey, Rick Dujay, Museums of Western Colorado director Mike Perry, Clive Bailey—an exploration geologist—and WIT/Mesa State interns Angela Foster, Austin Mead, Jake Lenihan and Randi Elliot returned to the site to excavate the interior of the truncated stone pyramid. Mike Perry and Clive Bailey searched the area near the structure and photographed other stacked-stone edifices near the site for further study. David Bailey and Dujay excavated the interior of the pyramid structure, while Angela Foster, Austin Mead and Jake Lenihan used metal detectors around adjacent areas near the pyramid to look for possible metallic artifacts. Artist Randi Elliot made several drawings of the stone structure. Dujay removed layers of dead foliage and debris from the top layer of the structure and, after digging down ten inches, found an object that looked like a nineteenth-century muffin-style military button. Dujay tested the object later at the Mesa State Electron Microscopy Lab and found that the button had an iron core and had originally been brass plated, consistent with nineteenth-century technology.

Back at the museum, David Bailey researched military buttons from the pre- and post–Civil War eras. He found that the button closely resembled an 1850s-style military button and was from the same era as the Masonic relic discovered in 1961. He thought perhaps an unknown group may have excavated the stone structure out of curiosity in the 1850s. Bailey was worried that important artifacts explaining the significance of the stone structure may have been removed by early treasure hunters. Unfortunately, treasure hunters and looters are not a recent innovation, and sites that could reveal so much information about the past have been recklessly destroyed.

The Masonic sword scabbard fragment and the military muffin button both dated from the mid-nineteenth century, and these artifacts may have been from a military unit of that period that was traveling through the area. Often, U.S. Army soldiers were also members of Masonic lodges, and their swords reflected their affiliation. Kannah Creek was a source of fresh, clean mountain water from Grand Mesa and was a campsite for early survey and military expeditions passing through the valley. Kannah Creek residents told the team of additional stone structures overgrown or in ruins in the area. The team documented and photographed several of these sites from 2007 to 2010. In the book *Tales of the Colorado Pioneers*, by Alice Polk Hill, Bailey found an 1882 account of a hunting party that looked down from the edge

Rick Dujay found this heavily corroded muffin-style military button buried inside the truncated pyramid stone structure. *Museums of Western Colorado.*

of Grand Mesa and sighted fifteen miles of stacked-stone fence. This meant that some of the stacked-stone structures predated the settlement era of Kannah Creek in the late 1880s. The group interpreted the ruins as game drives created by Native Americans to trap and hunt large game. Bailey and Dujay found that several of the stacked-stone sites were from nineteenth-century occupation.

On April 24, 2010, WIT crew leaders David Bailey and Rick Dujay, assisted by four interns and three volunteers, went to the location of a mysterious 145-foot stacked-stone wall partially buried in a hillside near the Kannah Creek valley. Dujay had heard about the site from area residents who discovered it after a fire burned away brush and debris. Dujay and Bailey theorized the wall might have been used as a defensive position at the junction of Kannah Creek and the lower portion of the old Ute Trail. One of the WIT expedition's members, Colorado Mesa University student Brandon Mauk, found an archaic .75-caliber round stone shot ball, a type that was often used in small Spanish colonial swivel cannons. The stone

Heavily overgrown remnant of a stacked-stone wall corner. *Museums of Western Colorado.*

shot was effective when fired at hard surfaces, such as a boulder or rock wall, because it would shatter into deadly fragments that would stop multiple combatants. The team also documented a ten-foot section of the wall that was largely intact. Bailey took the artifact to Dr. Mark Ryan's office in Grand Junction. Dr. Ryan used a state-of-the-art X-ray digital scanner to examine the shot ball and found that it was an extremely dense sphere with very few surface striations.

On May 16, 2010, the Western Investigations Team did a visual survey of the west and east bases of the partially buried 145-foot wall. They were trying to determine if there was more evidence of firearm activity after the recent discovery of the .75-caliber ball.

The team returned on July 16, 2010, to finish examining the 145-foot stone wall, and honey-colored pieces of gun flint were found by WIT/Mesa State interns Brandon Mauk, Caleb Carey, David Foster and Russell Baker. The team conducted additional excavation work at the truncated pyramid stone structure, and Dr. Rick Dujay uncovered a trigger guard buried against the southern wall of the structure. It was not a modern machined trigger

The 145-foot stacked-stone wall discovered by the WIT. *Museums of Western Colorado.*

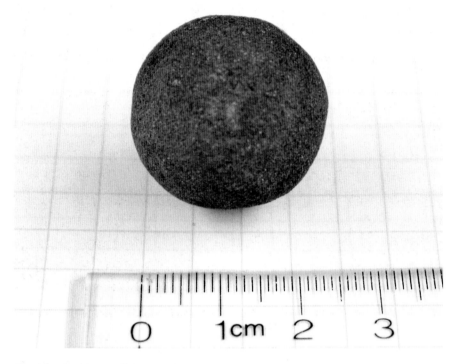

Spanish colonial .75-caliber stone shot ball. *Museums of Western Colorado.*

guard but was forged and hammered by a blacksmith. The discovery of the stone shot ball, gunflint and trigger guard made the team wonder if it had stumbled onto an early battlefield.

In January 2011, Dujay conducted extensive laboratory analysis of the .75-caliber stone shot ball found by Brandon Mauk at the stacked-stone wall in Kannah Creek valley. Dujay used the new Leica digital viewing microscope at Mesa State College (now Colorado Mesa University). The scope located iron, tin, cooper and zinc crystals imbedded in the ball consistent with being discharged from an early firearm. They realized this testing may have opened a new way to analyze shot balls from early swivel guns and cannons. By studying the imbedded metallic crystals, shot balls could potentially be dated to the historic period when they were fired. The shot ball, traveling at high velocity down the barrel, picks up metal crystals from the inner surface of the barrel, and they are deposited on the fired munition. Theoretically, the tested shot ball could render information on the date the cannon was cast by studying which types of metals were used in period firearms and small cannons.

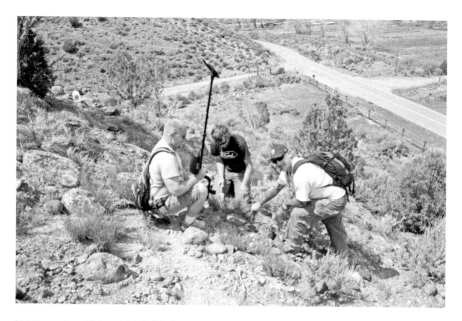

WIT members (*left to right*) Caleb Carey, Micah Maleu and Brandon Mauk examine the wall site near the Kannah Creek valley. *Museums of Western Colorado.*

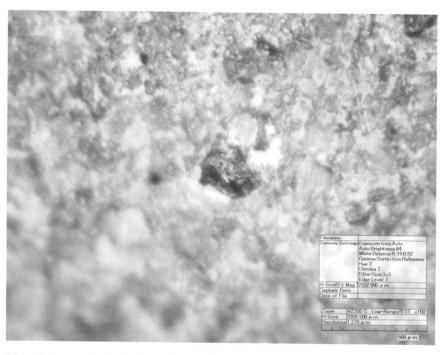

Magnified view of imbedded metallic crystals on the shot ball. *Museums of Western Colorado.*

Dujay and Bailey felt the discovery of the various firearm-related artifacts might indicate that the wall was an early defensive position because of its strategic location near the northern branch of the Spanish Trail and lower Ute Trail and its position on a hillside above the Kannah Creek valley. Bailey thought the stone shot ball probably was used during the Spanish colonial period. WIT director Bailey, who is also the curator of firearms at the Museums of Western Colorado, wondered if the trigger guard found near the site was also from the Spanish colonial era. He noticed that the inside opening of the trigger guard was made large enough for a gloved or armored hand to fit in and pull the trigger. The back of the trigger guard was straight, and the front curved area was designed to be inserted instead of fastened to the firearm. Bailey found almost identical trigger guards in photographs of sixteenth-century wheellock pistols.

On December 3, 2011, the WIT returned to the Kannah Creek site to attempt to seek definitive answers about the four-sided stone structure. The new search was the result of discovery of the trigger guard found the previous July at the site. When the stone structure was discovered, Dujay thought it looked like a rifle pit—a defensive bunker used to protect riflemen. Bailey agreed with Dujay, and both believed the structure was a hastily built early defensive fortification known as a redoubt. The site was then officially named the Redoubt Site. Dujay, Colorado Mesa University professor Susan Longest, David Bailey and WIT/Colorado Mesa University students Brandon Mauk, Amelia Bussell, Dani Paszek, Greg Johnson and Marryssa Russell set out to explore the site. The team set up a grid system around the stone structure and used metal detectors to search for additional fragments of the wheellock pistol or any other diagnostic artifacts. Amazingly, Marryssa Russell and Greg Johnson uncovered curved metal armor-like fragments on a slope below the Redoubt Site. Johnson also found an L-shaped Spanish colonial–style nail and an iron billet typically used by Spanish colonial blacksmiths for stock iron to repair equipment. Dani Paszek also discovered five campfires aligned in a straight row in a flat area behind the Redoubt Site near the bank of Kannah Creek. The discovery of five campfires equally spaced and in a straight row was indicative of a military-style encampment. The team was excited by its discoveries, but it tempered its enthusiasm until the artifacts could be scientifically tested. Bailey speculated that this was an unknown Spanish colonial military encampment that had slipped through the cracks of history.

Shortly after the expedition, Dujay and his student interns returned to the Wubben Science Center at Colorado Mesa University (CMU) and

Left: Reenactment of Spanish soldier firing a swivel cannon. *Museums of Western Colorado.*

Below: Wheellock trigger guard. *Museums of Western Colorado.*

Large fragment of Spanish colonial armor discovered near the Redoubt Site. *Museums of Western Colorado.*

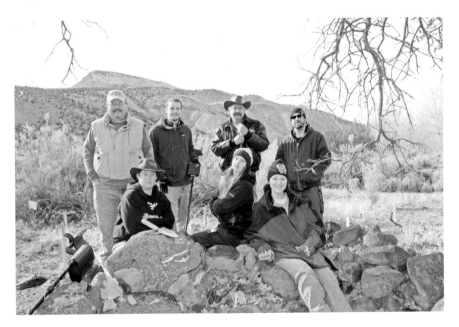

The WIT at the Redoubt Site, (*left to right*) WIT director David Bailey, Dani Paszek, Greg Johnson, Marryssa Russell, WIT scientific coordinator Rick Dujay, Amelia Bussell and Brandon Mauk. *Museums of Western Colorado.*

used the Leica 3-D microscope to examine the metallurgic properties of the artifacts under extreme magnification. These micrographs indicated the era the metal may have been manufactured and the efficiency of the casting methods. Early casting methods involved packing carbon around iron and heating it to create steel. The micrographs indicated significant deposits of carbon slag and other impurities typically found in sixteenth- and seventeenth-century casting.

On March 7, 2012, Bailey and Dujay held a press conference at the CMU Electron Microscopy Lab to discuss their findings on the artifacts discovered at the Redoubt Site. The team announced that the metal armor fragments, wheellock trigger guard and iron billet were consistent with metallurgy from the sixteenth and seventeenth centuries.

The iron billet had one final surprise, a faint Spanish colonial *quinto*, or "fifth," tax stamp. Spanish colonial metals were stamped at the time to show the quinto tax had been paid to the king of Spain. The design of the crown in the tax stamp matched others from the sixteenth century. The team seemed to have found proof that an unknown early Spanish expedition traveled to present-day western Colorado.

The WIT presents its discoveries from the Redoubt Site at a press conference at Colorado Mesa University. *Museums of Western Colorado.*

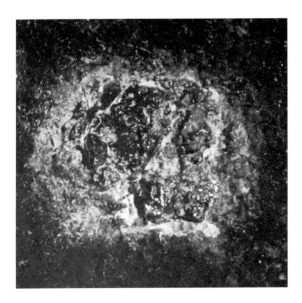

King of Spain's quinto stamp on the iron billet. *Museums of Western Colorado.*

The team returned to the Redoubt Site on March 24, 2012, with WIT crew leaders David Bailey and Rick Dujay, WIT archaeologist John Lindstrom, WIT volunteers Paul and Teresa Bussell and CMU student interns Amelia Bussell, Dani Paszek, Greg Johnson, Brandon Mauk and Marryssa Russell. The team logged the location of each artifact in proximity to the Redoubt Site. Each artifact location was photographed and soil conditions noted in preparation for a new archaeological site map. Amelia Bussell found a Spanish colonial forged iron ring at the site.

On August 17, 2012, during some more survey work at the site, CMU student intern Greg Johnson found an important Spanish colonial artifact. He discovered a large crudely threaded screw with a stylistically curved end piece lodged under a sagebrush. Bailey believed the ornate screw was possibly used to tighten the wheellock pistol's vice-like clamps, which held the pyrite in place.

On August 27, 2012, Ken Kosanke, a noted scientist with a doctorate in physical chemistry and postdoctoral work in nuclear physics, did additional testing on the Spanish colonial material found at the Redoubt Site. Kosanke tested the armor pieces, the iron billet and the recently discovered threaded screw. Kosanke used an energy dispersive X-ray fluorescence (EDXRF) machine at the CMU lab to determine the metallurgic makeup of the artifacts. The EDXRF machine bombards the artifacts with X-rays, which give off energy within a certain spectrum. The artifacts were compared to previously published metallurgy tests of

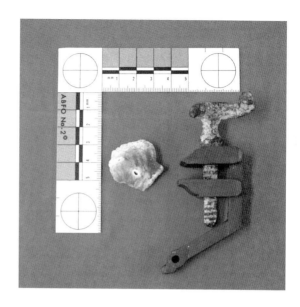

Ornate threaded screw in re-created wheellock jaws and gun flint. *Museums of Western Colorado.*

sixteenth- and seventeenth-century armor and the metallurgy testing at Colorado Mesa University, correlating the earlier findings of the WIT. The Western Investigations Team's metallurgic testing showed that the Redoubt Site artifacts predated the known Spanish colonial expeditions by about two hundred years. Southwest lore is full of lost conquistadors and expeditions that disappeared without a trace. The team had discovered fragments of armor, a wheellock pistol trigger guard and a stamped Spanish colonial billet. However, historical quests are never easy to solve, even with substantial evidence. Several archaeologists suggested the Redoubt Site might have been a Ute trading site. The Utes could have gathered old armor fragments and iron remnants after the Pueblo Revolt in 1680 and traded the iron at a campsite that might have predated the stone structure. The campfires, washed clean of their charcoal remnants by flooding, might have been from a later military exploration. The design of the Redoubt Site's stacked-stone structure, shaped like a truncated pyramid and near a Masonic relic, could have been evidence of a mid-nineteenth-century outdoor Masonic lodge.

David Bailey felt the discoveries of the Spanish colonial artifacts was very significant, but further evidence was needed to unravel the mystery of the Redoubt Site. He decided to reexamine the artifacts found at the Redoubt and Stone Wall Sites to determine if they were randomly collected metal fragments or if they were stylistically and functionally from the same time period. If the Kannah Creek artifacts could collectively be dated to the same

period, it would be further evidence they belonged to an unknown Spanish colonial expedition.

Bailey decided to start his own historical investigation, which would last several years, studying wheellock pistols, because their design varied over time, and the wheellock parts they found might give insight into the date of the expedition. He discovered that the first wheellock firearms mentioned in the West were used during Don Juan Oñate's 1598 expedition to present-day northern New Mexico. Oñate's treasurer, Don Luis Gasco de Velasco, listed in his personal inventory three wheellock firearms with large and small powder horns, bullet molds and other necessary supplies. Bailey's study indicated that forged wheellock trigger guards like the one Dujay discovered at the Redoubt Site were used on early wheellocks. The trigger guards were often damaged or destroyed with heavy use, and replacements were made by Spanish colonial blacksmiths. The later trigger guards for wheellocks were wider, more durable and had large screws to attach them more securely to the firearms.

Bailey found that wheellock pistols were invented in the early 1500s. The pistols had a spring-loaded wheel mechanism that was wound up like an old alarm clock and had a vice-like arm (doghead) holding a small piece of pyrite. Once the geared wheel was released, the pyrite set against wheel created sparks that ignited the gunpowder in the barrel and fired the projectile. Spanish colonial historians and archaeologists assumed that wheellock pistols used by Spanish explorers used pyrite and not a flint ignition system. Bailey found very little historical research about the earliest wheellocks. He located an out-of-print book on early Spanish firearms at a London, England bookstore. The book, entitled *A History of Spanish Firearms*, was written by William & Mary professor James D. Levin, an expert on Spanish firearms and armor, who mentioned that early Spanish wheellocks did not use pyrite as their ignition system but instead used flint. Levin said these wheellock weapons were known in Spanish as *llaves de pedernal* or "keys of flint." These wheellocks used an unusual fan-shaped flint to create friction on the wheel mechanism. The Western Investigations Team had found similar honey-colored, fan-shaped flints at the Stone Wall Site in addition to the wheellock pistol artifacts at the nearby Redoubt Site.

Bailey completed further research at Spanish colonial archaeological sites across the United States and found that flints similar to those discovered at the Redoubt Site and the Stone Wall Site had been unearthed at other sites. These honey-colored flints had a fan shape and flat edge at the bottom almost like the outline of a clam shell. Archaeologists referred to these as

spall-type gunflints and indicated they were made from nearby sources, not imported from European flint suppliers. Bailey's research indicated that these spall flints might have been specifically made for early Spanish flint wheellocks and could change the interpretation at many historical sites across the country.

David Bailey, Rick Dujay and museum employee Cecil Wilkinson decided to reinvestigate the area where the wheellock trigger guard and ornate screw were found. On November 22, 2014, the group found an unusual triangular dagger blade with a metal detector close to the location of the ornate screw discovery. This rondel-style sixteenth-century dagger blade was used by Spanish colonial soldiers to inflict the most amount damage to their enemy. The triangular shape of the blade created a wound that was hard to stop from bleeding.

On a visit to Baltimore, Maryland, Bailey visited the world-famous Walters Art Museum. The museum has an incredible collection of wheellock pistols. He sketched and photographed the various wheellocks on display. Bailey realized the threaded screw with the ornate handle they found at the Redoubt Site was an essential part of a wheellock pistol. He discovered it was the screw to tighten wheellock dog jaws and hold the flint for contact with the wheel mechanism. Bailey found that early Spanish doghead screws had ornate handles until the late 1590s and were eventually replaced with more utilitarian screw heads without handles.

Although many of the artifacts recovered from the Redoubt Site date to the 1590s, the question remained: were the artifacts from an early Spanish

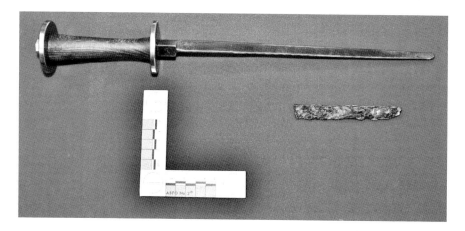

Replica of a rondel-style fighting knife with the actual triangular blade found near the Redoubt Site. *Museums of Western Colorado.*

Model of wheellock pistol without the ornate screw used to hold the flint in place. *Museums of Western Colorado.*

expedition? Bailey believed the evidence was strong; all the artifacts found at or near the Redoubt Site dated from the sixteenth century. This included the wheellock trigger guard, flints, an early ornate doghead screw, a swivel cannon stone shot ball and the recently found rondel-style dagger blade.

On July 29, 2016, Bailey gave a digital presentation at the national meeting of the Old Spanish Trail Association Conference in Grand Junction. Participants came from all over the nation, including BLM and National Park Service archaeologists, Spanish colonial historians, cartographers and ecological scientists. Bailey's presentation focused on new scientific methods used to date Spanish colonial metallurgic artifacts at the Redoubt Site. He discussed Dujay's use of the Leica 3-D microscope to determine the types of metallurgic debris on fired shot balls. Bailey also discussed his new research on early Spanish colonial wheellock pistols that used flint instead of pyrite to ignite gunpowder. Bailey's conference presentation was a tremendous success and challenged Southwest scholars', historians' and archaeologists' long-held beliefs about the early Spanish exploration of western Colorado.

Bailey found that after the failure of the Coronado expedition in 1540, many Spaniards wanted to make another attempt to explore the norther frontier. In 1562, Spanish official Alonso de Zorita asked the Spanish government to fund a new expedition. The government denied his request to fund another costly expedition. Bailey wondered if the artifacts found at the Redoubt Site were the result of a privately funded group of soldier-adventurers who headed north in search of riches and met their destiny far from home. The high desert of Kannah Creek valley does not easily give up its secrets.

CHAPTER 4

CHASING A DREAM OF GOLD

Western Investigations Team director David Bailey was interested in examining what motivated the early Spanish colonial explorers to investigate the dangerous northern frontier, which encompassed present-day western Colorado. The WIT members enjoy their experience of working at historical and archaeological sites. The thrill of discovery is what the public hears about from the media outlets covering a story. However, behind the scenes, it takes months and sometimes years of historical research to determine where a specific site is located, what the team might expect to find and how the site fits into our regional history.

Bailey found that Spanish colonial historians emphasized the importance of Spanish exploration in opening the American West and Southwest to trade and eventually settlements. What is often overlooked is an explanation of the motivation for these explorers to travel into unknown and often dangerous lands. Bailey traced the Spanish explorers' interest in Colorado all the way back to the beginning of their conquest of the New World. Bailey began with Spain's first conquistador, Hernan Cortés, conqueror of the Aztecs. Bailey discovered that Cortés and his fellow conquistadors were very interested in native stories, legends and myths. They were looking for any information that would lead them to rich cities they could plunder and to take control of the new lands for the king of Spain. In a long letter to Emperor Charles V, Cortés tells of his first conversation with the Aztec ruler Montezuma on November 8, 1519, on the eve of the destruction of the Aztec Empire. Montezuma confided:

"Meeting of Cortes and Montezuma." Illustration by Godwin for William Dalton, *Stories of the Conquest of Mexico and Peru, with a Sketch from of the Early Adventures of Spanish in the New World—Retold for Youth* (London, 1872), 176–77.

We have known for a long time, from the chronicles of our forefathers, that neither I, nor those who inhabit this country, are descendants from the aborigines of it, but from strangers who came to it from very distant parts; and we also hold, that our race was brought to these parts by a lord, whose vassals they all were, and who returned to his native country.

Cortés conjectured if it was possible to locate their original kingdom, which the Aztecs called Aztlán. He expected it would be just as wealthy as the newly discovered Aztec kingdom. Bailey was surprised to discover that the Seven Cities of Gold legend did not originate in the Southwest of the present-day United States but from Spain. In AD 711, the Moorish army invaded Spain and Portugal, and seven bishops and their followers sailed west to avoid the invaders. The bishops then founded Seven Cities of Gold on an island in the Atlantic Ocean. However, by 1508, maps appeared in Europe that relocated the Seven Cities of Gold to North America. Aztec priests told the Spanish conquistadors their creation story of the emergence of their earliest ancestors from seven sacred caves. It was not long before the Spanish put the seven cities and seven caves stories together and believed the Aztecs were originally from the Seven Cities of Gold.

Hernan Cortés was determined to be the first to find the rich Aztec homeland. He dispatched his lieutenants to search for possible rich mining regions or a water passage to the South Sea (Pacific Ocean) in an unexplored area west of Tenochtitlán (present-day Mexico City). The Spaniards founded a port at Zacatula (Bahía Petacalco), on the west coast of Mexico. Cortés built four small ships to explore the coastline of the South Sea. He also believed strongly in another myth, the Strait of Anián, a large waterway that supposedly bisected North America from the Pacific Ocean to the Atlantic Ocean. On the banks of that waterway would be rich kingdoms and possibly the Seven Cities of Gold. Bailey considered this myth that explorers must travel inland on a great waterway to find the golden cities, the start of the Spanish quest toward present-day western Colorado.

Bailey noticed that many Spanish exploration documents and maps were altered to prevent the information from falling into the hands of other foreign powers, like France. On May 15, 1535, Cortés wrote a letter shortly after his discovery of Santa Cruz (La Paz, Mexico) about his treasure expeditions. However, the section of his letter explaining his supposed treasure discoveries and secrets was mysteriously removed after it was received. Spanish colonial treasure hunters were extremely secretive about the information they gathered from explorations, and it is not surprising

that this section is missing. The surviving section of the letter does mention pearls, and one can sense his disappointment in not finding a vast treasure and his anxiousness to find other riches.

When Cortés returned to Mexico, he claimed to have discussed his findings with Friar Marcos de Niza. In 1538, the viceroy of New Spain, Antonio de Mendoza, sent Niza on an overland mission to explore the country east of the Sea of Cortés (Gulf of California). Niza came back with the news of the existence of the Seven Cities of Cibola (later known as the Seven Cities of Gold). The news would later send explorer Francisco Vásquez de Coronado on a disastrous quest to find the mysterious cities in 1540.

Coronado traveled for two long years looking for riches. He was told of another great city, Quivera, which after an extensive search turned out to be just another myth. Coronado returned to Mexico bankrupt and disgraced after his failure to find riches on the northern frontier. The attention Niza was receiving for his "discoveries" greatly upset Hernan Cortés. From 1521 to 1539, Cortés financed numerous land and sea expeditions in search of rich cities and kingdoms, chasing myths based on legends and stories from native peoples. The expeditions found no great cities or treasure on the banks of the mythical Strait of Anián, only more stories of great riches from native groups they encountered. In 1541, Hernan Cortés left Mexico to settle legal issues with the king of Spain and never returned. However, after Cortés's death in 1547, a map was found at his Spanish residence. The map was drawn by explorer Domingo del Castillo in 1541 and showed that north of the Gulf of California was a river called the Rio de Buena Guia, known today as the Colorado River. The map indicated that if one sailed inland, one would reach the legendary city of Cibola at 37 degrees north latitude. The Spanish quest for mythical kingdoms was approaching ever closer to western Colorado.

After Cortés's treasure quest, one of his veteran soldiers, Juan Rodríguez Cabrillo, carried on the search for the treasure cities. He had fought the Aztecs with Cortés and had become a favorite of the Spanish government. Viceroy Antonio de Mendoza asked him to lead an expedition to the South Sea to look for the Strait of Anián. On June 27, 1542, Cabrillo set out with three ships and headed north toward the coastline of the South Sea (the California coast). The trip was uneventful until August 25, 1542, when Cabrillo and his men encountered five natives who indicated through sign language that they had seen other men like them with beards, dogs, crossbows and swords. The native men had decorated themselves with white paint that mimicked coats, trousers and ornamental sashes. They indicated

the Spaniards were five days' travel from them. On October 8, 1542, an Indian elder told them again that there were other Spaniards traveling on the mainland. Native villages all along the coast told the same tale of mysterious bearded men wearing similar Spanish-style clothing.

Bailey had previously encountered this persistent myth about lost Spaniards living inland. This myth would last for centuries and take its place alongside the legend of the Seven Cities of Gold and the Strait of Anián. The Cabrillo expedition would return to Mexico after a nine-and-a-half-month trip without its leader, who died of a fall during the expedition. Although the Cabrillo expedition found no riches, it did add valuable information on the geography and native groups of the California coast.

Luckily for Bailey, the Spanish colonial government kept excellent records in the form of maps, diaries and ledgers to enlighten the king of Spain on his newly conquered lands. The full story of the Spanish pursuit of legends and myths began to unfold with the Joan Martines map and the ultimate journey to present-day Colorado.

Cartographer Joan Martines lived in Messina, Sicily. From 1550 to 1591, he produced over thirty charts and atlases. Phillip II of Spain made him royal cartographer in 1591. Martines became one of the most celebrated mapmakers of his time. Bailey was astounded that Martines's map marked the area of present-day west-central Colorado as the site of the Seven Cities of Gold. The Martines map indicated that the cities were at the intersection of 39 degrees north latitude and the source of a large unknown river, apparently the Colorado River of today, which emptied out in the Gulf of Mexico.

The geographical information of these early maps was based partially on the Spanish conquistadors' and the European cartographers' limited knowledge of the coastlines and inland topography of the New World. However, many early mapmakers based much of their information on legends, myths and cultural stories told by the native peoples. These mapmakers went one step further by placing mythical cities on their maps with no factual information.

Spanish adventurer Sebastián Vizcaíno sailed up the California coast in 1602 and ran into more strange tales of lost Spaniards. On November 10, 1602, Father Ascensión, who accompanied Vizcaíno, related that after their arrival at San Diego Bay, they encountered native men on shore with silver ore samples. The men indicated that other bearded Spaniards wearing collars and breeches were living inland and had the same type of ore in their possession. When the Vizcaíno expedition arrived at present-day Santa

Catalina Island, his diary entry dated November 30, 1602, stated that an elderly native woman brought two pieces of Chinese silk with figures on them to the attention of the crew. The woman explained that men dressed like them were shipwrecked on the coast long ago. Father Ascensión was so concerned with these native sightings of European-like strangers that he asked the king of Spain to send an expedition to locate them. At that time, the Spanish Empire was worried that other European nations were trying to encroach on its territory. Although the king never acted on Father Ascensión's recommendation, Bailey realized the Cabrillo and Vizcaíno expeditions had engrained in the Spanish psyche the notion of lost Spaniards and mysterious cities in the wilds of North America.

Bailey found that the numerous stories of mysterious Spaniards and settlements reported by the maritime explorers were strengthened by the reports of Spanish priests who interviewed native peoples during their travels in the present-day Southwest of the United States. Of interest was Father Alonso de Benavides's royal report of 1630. He traveled to many areas in the Southwest and recorded the different lives and customs of native groups, the mineral resources and legendary places. Benavides's report gave coordinates for finding the legendary kingdom of Quivera. Benavides indicated that the Quivera Indians adorned themselves with gold earrings and necklaces and that precious metal was commonplace in their kingdom. Father Benavides presented his report to the Spanish royal court in hopes of receiving more priests and money to continue the religious work in New Spain. Benavides's narrative of the Seven Cities of Sibola (Cibola) described one of the seven cities, Sibola, as consisting of a thousand beautiful three- to four-story timber-and-stone houses. Benavides's report gave legitimacy to long-enduring and pervasive myths in the region.

Fifty-six years later, a second geographical description of New Spain was published, Alonso de Posada's royal report of 1686, which mentioned the important kingdom and provinces of Teguayo, on the northern frontier. Posada gave directions to this new kingdom. If travelers left Santa Fe, located at 37 degrees north latitude, proceeded northwest and crossed a large river (Colorado River), they would enter the country of the Utes (present-day western Colorado). Approximately seventy leagues from this country, they would cross into Teguayo, also called Copala, the ancient homeland of the Mexicans. The report stated that all people of Central and South America originally came from this region. Bailey noticed that Cortés's old legend of the Aztec homeland had resurfaced and must have rekindled interest in finding the rich cities and treasure. This report also reinforced the Spanish

belief of unknown kingdoms not far from a great river and above 37 degrees north latitude. The royal reports of Benavides and Posada were largely based on information from many sources, including soldiers, traders and native peoples.

Nearly eighty years after the Benavides and Posada reports, another explorer, Juan María Antonio Rivera, would attempt to solve the mysteries of the northern frontier. By 1765, the Spanish government had become worried about the uneasy northern alliances with the Comanche and Ute Nations. New Mexican provincial governor Tomás Vélez Cachupín sent an expedition to the unexplored northern frontier to reconnoiter the situation.

Juan María Antonio Rivera was chosen to lead two expeditions to Ute country. He kept detailed diaries of each of his trips. In June 1765, Rivera and a group of experienced trappers and traders left for "the northern mystery," a Spanish term for the uncharted area north of New Mexico, which includes present-day Colorado and Utah. Rivera was also told by the governor to investigate where a Ute warrior had found a piece of silver ore traded to a New Mexican blacksmith. The expedition traveled uneventfully to Ute country (present-day western Colorado) and investigated possible locations of silver deposits with no success. The Utes told Rivera that on the other side of the Río del Tizón (Colorado River) were bearded white men who dressed in armor and wore metal hats. Bailey thought Rivera must have been intrigued with this revelation because many of the maps of his day located the southernmost metropolis of the Seven Cities of Gold at 39 degrees north latitude.

Many historians believe Rivera reached as far west as present-day Delta, Colorado. This put Rivera's expedition about fifteen Spanish leagues (a Spanish league is equivalent to 2.6 miles) south of the first of the seven fabled cities that were listed on the Didier Robert de Vaugondy map, published in 1772.

The Utes convinced the Spanish that it was too dangerous to travel any farther north because of hostile tribes, and Rivera and his men returned to New Mexico. In October 1765, Rivera was sent on a second mission by Governor Cachupín to find the Río del Tizón and look for bearded men (possibly Spanish) living in towns or nations along its banks. The Utes were again hesitant to take Rivera to the river because of the danger. In his diary, Rivera said he finally was guided to the Río del Tizón but at the wrong place.

Rivera's diary of his 1765 expedition had an unusual story about a woman living with the mysterious men wearing Spanish-style armor. The Utes told Rivera that women who lived with the bearded, armored men wore metal

decorative armlets and braided their hair in a Spanish style. Rivera makes a point of mentioning that one of the women in the story was named Castira, which he said in Spanish was Castilla. Bailey found it was odd the Utes, who had almost no information on this mystery colony, would know one specific name. Spanish diaries and maps often contained cryptic messages only understood by the author or mapmaker in case the information was lost or stolen. Bailey wondered if Castira was a code word for something else. He researched the word and found no reference in any modern dictionaries or lexicons. It occurred to him to reference eighteenth-century books, and there the answer was found. The word *castira* was in an early history of Ireland entitled *Collectanea de Rebus Hibernicis*, written by Charles Vallancey in 1786. Vallancey explained that the word was a geologic term meaning "Royal Oar [ore], concealed in the earth." The other interesting word choice by Rivera was Castilla, which is a region of Spain but also means "castle." Bailey surmised that Rivera was close to or had information on one of the seven cities and thought he needed to disguise the reference to the golden city. The Utes finally told Rivera that the lost Spaniards he was looking for were killed in a battle. Rivera, disillusioned by his lack of success, returned to New Mexico.

In 1775, Father Silvestre Vélez Escalante sent numerous letters and plans to the governor of New Mexico and the provincial minister of the Franciscans asking for permission to find an overland route from New Mexico to the Spanish mission in Monterey, California. By 1776, Escalante's plan was approved, and he traveled to Santa Fe to pick up supplies and find capable men to go on the expedition.

Father Silvestre Vélez Escalante was born in Trenceño, Spain, in 1750. At seventeen, he joined the Franciscan Order and traveled to Mexico. Escalante was transferred to New Mexico to conduct missionary work and taught Christian doctrine at the Zuñi mission. Escalante traveled extensively across the northern frontier and made use of the Spanish missions' extensive libraries, where he reviewed the available histories on northern exploration and contemplated an overland expedition from New Mexico to the Spanish mission in Monterey, California. If a land route were established, it would improve communication and coordination of mission work with the West Coast missions and communities. Bailey found it fascinating that Escalante was also caught up in the myth of the lost Spaniards and interested in solving the mystery of a colony of lost Spaniards living on the northern frontier. In a letter dated October 28, 1775, to Governor Don Pedro Fermín de Mendinueta, Escalante wrote:

It must be forty years since reports of the said Spaniards were first had. It was printed in the diary of the journey of the year of [17]51 which Father Fernando Consag made through California. Because the settlement of Monterrey is much more modern, it is inferred evidently that the Spaniards who have been seen on the other side of the great river of Tison [present-day Colorado River] *cannot be from there. In circumstances wherein two nations so different as are the Californians and the Utes find themselves in accord, I myself, not having received further reports for so long a time, suppose that some shipwreck or other contingency threw upon the coasts of Monterrey some European people and that they, having penetrated inland, established themselves on the banks of the said river and that finally their descendants are those whom the Utes and the rest, perhaps because of the color and dress, call Spaniards. Their discovery would be very useful to religions and the crown both to prevent any attack upon this kingdom, if they are foreigners, and to incorporate them with ourselves if they are, as they say, Spaniards.*

By 1775, Escalante's expedition included Father Francisco Atanasio Domínguez and Don Bernardo de Miera y Pacheco, a well-known surveyor and mapmaker, as well as seven experienced traders and townsmen. After several delays, the men left Santa Fe on July 29, 1776. Their journey took them through the present-day areas of Northern New Mexico, western Colorado, Utah and back down through Arizona.

Severe winter weather stopped them from attempting to reach Monterey. Escalante kept a detailed diary of their trip and reported on flora, fauna, native groups and terrain. On September 30, 1776, his diary entry described twenty bearded native men resembling Spaniards who came into their camp south of present-day Utah Lake, Utah. Escalante speculated that, since they crossed the Tizón earlier on their trip, perhaps these were the "lost Spaniards" the Utes had talked about. The expedition arrived back in Santa Fe on January 2, 1777, having failed in its mission but with valuable new knowledge of the northern frontier.

On April 2, 1778, Escalante wrote Father Juan Agustín Morfi a letter that reiterated his theory that the "Spaniards" living across the Río del Tizón (Colorado River) were the bearded natives he met on his expedition in 1776. Father Vélez Escalante's new theory did not stop the centuries-old search for the lost Spaniards and their colony.

Bailey found reference to one last Spanish expedition to find their lost countrymen. In 1811, Don José Rafael Sarraceno, a prominent citizen

of Santa Fe and postmaster of New Mexico, made a trip to the northern frontier to chase after the story of a lost Spanish colony. Sarraceno wanted to find the Spanish settlement the Utes said was beyond their border. He traveled for three months searching for the settlement and stopped at a large river, which may have been the Colorado; natives told him they traded for items with people who lived on the other side of the river. Sarraceno failed to find a river crossing to the north and west and returned home to Santa Fe.

Bailey's research brought to light the prominence that western Colorado played in Spanish lore, both as the unattainable location of the Seven Cities of Gold and as place early Spanish explorers came to looking for wealth and information about the mysterious northern frontier.

CHAPTER 5

COLLBRAN MYSTERY FLOOR

I n June 2005, the newly formed WIT decided to explore the mystery of an ancient floor discovery near Collbran, Colorado. Dr. Mike Ryan told the story of the mystery floor to WIT director David Bailey while they were staying at Tom Kenney's cabin with their families. Ryan said Kenney found the buried floor near the cabin while digging a cellar. Bailey believed it would be a great mystery for the Western Investigations Team to research if they could find more information about the floor's exact location. WIT researcher Susan Corey, while working at the Museums of Western Colorado's Loyd Files Research Library, found a May 3, 1937 article describing the mystery floor.

The *Grand Junction Daily Sentinel* reported that archaeological evidence of a prehistoric civilization was discovered at the Kenney Ranch, north of Collbran. The newspaper article gave a description of the floor:

> *The find consists of a beautiful and carefully laid pavement made of flat hewn blocks of sandstone neatly fitted together. The work is 8 feet below the surface of a long gentle slope with an altitude of 7,148 feet above sea level. The stones plainly show they have been worked and fitted together. They are laid in straight lines and shaped to one another in a manner that is strikingly like modern masonry. At one corner of the tiled pavement was found a spring and the stones are perfectly rounded off to form an opening through which to dip water. His* [Tom Kenney's] *excavation now is about five feet wide and ten feet long. The entire work was covered*

PAGE EIGHT

EVIDENCE OF PREHISTORIC CIVILIZATION IS FOUND AT RANCH NORTH OF COLLBRAN

Evidence of a prehistoric civilization has been uncovered by Tom Kenney on his ranch 4½ miles north of Collbran. During some excavation work Kenney dug into a flag stone pavement laid by human hand and immediately realized that he had discovered undisputable evidence of very early inhabitants on the south slope of Battlement mesa.

The find consists of a beautiful and carefully laid pavement made of flat hewn blocks of sandstone neatly fitted together. The work is 8 feet below the surface of a long gentle slope with an altitude of 7,148 feet above sea level.

The stones plainly show they have been worked and fitted together. They are laid in straight lines and shaped to one another in a manner that is strikingly like modern masonry. At one corner of the tiled pavement was found a spring and the stones are perfectly rounded off to form an opening through which to dip water.

His excavation now is about five feet wide and ten feet long. The entire work was covered with river deposit eight feet in thickness. The sand stone blocks are all about 4 inches thick and are matched perfectly.

ROYALTY OF ENGLAND TO BE WELL PAID

Princess Elizabeth Gets $30,000 Annually; Duke of Windsor Not Mentioned

London, May 3. (AP)—Princess Elisabeth, pretty 11-year-old heir presumptive to the British throne, was recommended today for an annual grant of £6,000 (30,000) in a report of the common civil list committee.

The duke of Windsor who gave

The *Grand Junction Daily Sentinel*'s article describing the Collbran mystery floor in 1937. *Museums of Western Colorado.*

with river deposit eight feet in thickness. The sandstone blocks are all about 4 inches thick and are matched perfectly.

The article mentions that Al Look, well-known amateur paleontologist and archaeologist, accompanied by Grand Junction luminaries Dean Pitts, W.W. Wood, Dr. B.C. Maynard and Al Look Jr., visited the Kenney Ranch discovery to determine if it was an actual archeological site. The men came

to the consensus that the floor was constructed by an ancient civilization. Look was impressed with the site and in the newspaper article stated: "The work is so well done, and the stones are so neatly together that he believes it far surpasses the work of the early southwestern Indians. The fact that it is deposited under eight feet of river deposit and nothing indicated on the surface makes it a very interesting find."

In 1946, a *Westways* magazine article described the excitement generated by the ancient floor discovery. Two archaeologists, one from Denver and the other from Chicago, traveled to see the floor in 1938 and were intrigued by the site. They in turn approached the Archaeological Society in London, England, which recommended an archaeologist who was currently studying an ancient tomb in Egypt. The London archaeologist arrived a month later at the ranch near Collbran. The three got in a heated argument about whether the floor was man-made or a natural occurrence, with the London archaeologist favoring the latter and the American archaeologists thinking it was a discovery of a lost civilization. Eventually, the floor was forgotten, and the mystery was unresolved. Unfortunately, the article failed to mention the names of the archaeologists involved, and there was not a method to track them down or locate any subsequent reports written about the site.

The Western Investigations Team decided its mission was to locate the floor and find out if it was an actual archaeological site or a natural geologic formation. The WIT crew contacted Mary Lou Ridenhour, Tom Kenney's daughter, who placed wood stakes at the location where she believed the floor had been originally excavated when she was a small child in 1937. Bailey contacted a local businessman in Grand Junction, and he agreed to lend the team a backhoe for three days.

On August 8, 2005, Museums of Western Colorado maintenance supervisor Don Kerven agreed to operate the backhoe and began carefully excavating between the stakes. The floor area was on a very steep slope and had been covered by tons of material washed down from the mountains above the site. After several hours of digging, the team wondered if it was in the right location. The WIT crew had removed about a thousand cubic feet of dirt with the backhoe and eventually uncovered a small section of the floor at a depth of ten feet. WIT archaeologist John Lindstrom carefully exposed the floor, and his two assistants carefully used iron rods to probe every few feet in order not to damage the floor. Bailey was amazed to find what looked like a carefully laid stone courtyard. The floor tiles had an unusual gold appearance and gave off a slight sparkle in the sunlight. Unfortunately, a

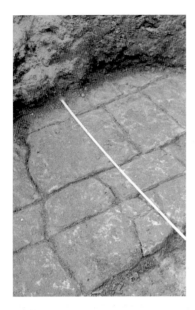

A small section of the Collbran floor at a depth of ten feet. *Museums of Western Colorado.*

The Collbran floor had the appearance of a carefully laid floor. *Museums of Western Colorado.*

hydraulic hose broke on the backhoe, and work at the site stopped until repairs were made the next day.

On August 9, WIT anthropologist Kim Murray and two of the WIT archaeologists, John Lindstrom and Zebulon Miracle, began to clear off a larger section of floor and look for evidence of man-made origin.

Bailey, Rick Dujay and other WIT volunteers each took an area of the floor to clear off and look for any diagnostic artifacts or period debris from the Kenny Ranch. The team discovered an antique shovel head and ladder lock in debris at floor level that could possibly be from the 1937 archaeological investigation. WIT archaeologist Phil Born also started a vertical profile map to document the layers of alluvial gravel, soil and debris that had accumulated on top of the floor. Eventually, the WIT crew, with the help of the backhoe, removed two thousand cubic feet of dirt and uncovered a large area of the floor. The floor had an extensive period of exposure to the elements, as evidenced by the heavy weathering on the stone tiles. The floor may have been uncovered for countless centuries. Dujay took samples of several spots on the exposed floor that had the appearance of being blackened by fire. However, Mesa State College laboratory testing confirmed it was naturally occurring iron oxidation of the sandstone floor tiles. Three consulting geologists, Larry Luebke, Bill Hood and Joe Fandrich, arrived at the site to determine if the floor was a naturally occurring geologic formation. The geologists determined

the floor was near a contact point between the Wasatch and Green River formations. They dug a test hole underneath the floor and found it had multiple layers of sandstone blocks. The geologists concluded the layers of stone had occurred naturally and through pressure had broken into smaller blocks that were perfectly shaped, of the same thickness and gave the appearance of cut stone laid by a stonemason. After careful examination, all three geologists concluded that the formation was a natural occurrence. The archaeologists concurred with the geologists that the floor was not an archaeological site after finding no artifacts or evidence of tool marks on the stone tiles. The mystery floor excavation site was carefully filled back in, and the team felt satisfied the mystery had been solved.

However, after returning from the dig site, Bailey was unable to find photographs of a similar formation that was level, of the same thickness and with bisected stones. Bailey had been told by a Collbran resident who visited the dig site that another formation like the floor was in the adjacent Dry Fork drainage. In 2007, Bailey sent two teams out to search for rock outcrops like the mystery floor. He surmised that if similar sites were found, it would confirm the floor was a natural occurrence. He acquired satellite

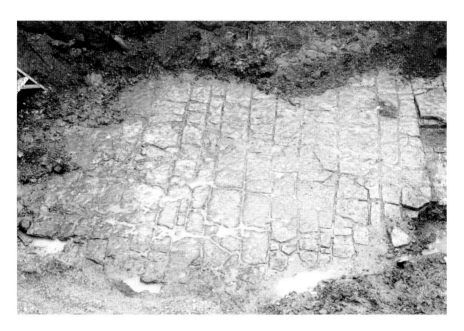

The heavily weathered floor had been exposed to the elements for a long period of time. *Museums of Western Colorado.*

photographs of the Kimball Creek area and consulted with several geologists on the logical place where similar outcrops would occur. A northern and southern site were chosen in the Dry Fork area approximately one mile west of the floor site.

On July 14, 2007, Dr. Mike Ryan, who was very familiar with the area, along with eight other hikers searched the southern Dry Fork site and found no evidence of a similar formation, although rock samples of the same composition as the floor were found. In early September, Dr. Ryan and WIT intern Jake Lenihan searched the second, northern area with no results. At the same time as the second hike, David Bailey and Mesa County surveyor Keith Corey surveyed the filled-in area above the floor site to complete the study of the floor and document its exact location.

In late September 2007, David Bailey finally discovered how the mystery floor was created after reading an article on unusual formations in the *Journal of Structural Geology*. He found out the stone formation is called orthogonal cross jointing, which creates unusual stresses, like applying pressure on a saltine cracker on all four sides at once and ending up with four uniform pieces. These individual pieces then shifted over time, creating a bisected floor appearance. Bailey's theory was confirmed when he found photographs of an orthogonal cross-jointed "floor" in Bosnia that looked identical to the one in Collbran. This new evidence further indicated that the Collbran mystery floor was a geologic phenomenon.

In 2009, David Bailey received an unusual request concerning the floor from Drexel University in Philadelphia, Pennsylvania. Michel Barsoum, distinguished professor in the Department of Materials Science and Engineering, wanted to test a sample of the floor tiles taken back to Museums of Western Colorado after the conclusion of the floor excavation. Barsoum developed a theory that the pyramids at Giza, Egypt, were not made of massive natural stone blocks but of blocks manufactured and cast on site. He had read about the Western Investigations Team's excavation of the mystery floor and believed those stone tiles were also castings. The WIT geologists had determined the floor was a natural occurrence and considered the debate on natural or man-made origins closed. However, Barsoum still requested Bailey to send small floor tile samples to test his man-made theory. Barsoum's student Aaron Sakulich, a doctoral candidate at Drexel, tested the Collbran floor samples as part of his thesis. Sakulich used a scanning electron microscope to analyze the floor samples, and the radiocarbon dating showed that the calcite was infinitely old and the floor was a natural phenomenon.

In 2010, Bailey returned to his research to look for any historical references that the floor was exposed during the Spanish colonial period or later during the Westward expansion and settlement period. The team had only three days to find and uncover the mystery floor and only exposed a small portion of it. Another mystery the team never solved was the location of the drinking spring with rounded stones to dip water. Bailey looked for any historical reference that a larger section of the floor was exposed during the historical period. He was hoping there might be a description about the actual size of the floor and if it was used as a campsite because of the floor spring. Bailey found very little information on the floor in the Westward expansion and settlement era except for a reference to the site in the 1941 edition of the Work Projects Administration guide book *Colorado: A Guide to the Highest State*. The book gave directions to the floor site: "Left from Collbran on an unnumbered side road to a partly excavated PUEBLO INDIAN RUINS, 2 mi.; this buried city promises to be of archaeological significance as it lies more than 200 miles from any previously discovered pueblo structures."

Bailey thought it was a bold assertion by the guidebook's authors to describe the partially uncovered stone floor as part of a lost, buried city. He next investigated the Spanish colonial documents about western Colorado for any possible descriptions of the floor site. This was a relatively easy task, because there were only two historically documented groups of Spanish explorers that visited present-day western Colorado. Juan María Antonio Rivera came to the area in June and October 1765, but these expeditions only got as far as the Gunnison River, near present-day Delta, Colorado. There were no historical records that Rivera's expedition ever ventured beyond the Gunnison River valley, and the floor site was nearly forty miles away in mountainous terrain.

In 1776, Father Francisco Atanasio Domínguez and Father Silvestre Veléz Escalante explored present-day western Colorado, Utah and Arizona in search for a route to Monterey, California. The fathers completed a 1,700-mile trek but were forced to journey south back to Santa Fe, New Mexico, after being stopped by severe winter weather. Bailey retraced the route Dominquez and Escalante took on their journey north through present-day western Colorado. Escalante's detailed diary and a map drawn by the expedition's talented cartographer, Don Bernardo de Miera y Pacheco, in 1779 gave historical researchers enough information to retrace their journey on a modern map of Colorado. The Dominguez and Escalante expedition left Santa Fe on July 29, 1776, entered western Colorado near present-day Aroboles and headed in a northwesterly direction near the present-day

towns of Ignacio, Durango and Dolores. At the time of their expedition, there were no towns or cities, but there were numerous Ute encampments. They continued in a northerly direction past Delta, where Juan María Antonio Rivera's expedition stopped and turned back in 1765. Dominguez and Escalante should have continued north along the Gunnison River to present-day Grand Junction and turned due west through the Grand Valley toward Monterey, California. Modern cartographers are perplexed why the Dominquez and Escalante expedition suddenly veered off its northern course just past Delta, Colorado. The travelers left the flat and relatively easy terrain of their route and traveled northeast past the present-day towns of Olathe and Paonia and then over the mountainous terrain of Grand Mesa. They journeyed north past Collbran and camped very close to the floor site. This difficult, circuitous route through the mountains contradicted what Escalante said in a letter to Friar Fernando Antonio and the governor of the province on October 28, 1775, before he left Santa Fe:

> *I consider better and shorter the route to which can be taken without coming down from the height of Monterey as far as the river to be crossed near the Yuta Payuchis (Southern Utes) who are near the Moqui (Hopi) on the north; these Indians may act as guides to travel in a straight line to this province. According to Vivas' maritime directory, printed in Manila in [17]66, the port of Monterey is in a latitude of 37 degrees and some minutes and according the newest map by Don Nicolas de Lofora, the town of Santa Fé is in a latitude of 36 degrees and 11 minutes, therefore, the Yutas Payuchis are, by my reckoning, in the same latitude as Monterey.*

Bailey's previous research revealed Escalante's obsession with trying to solve the mystery of a lost Spanish colony on the northern frontier. In 1775, Escalante wrote a letter to New Mexico governor Don Pedro Fermín de Mendinueta and mentioned that the Utes had seen Spaniards on the other side of the great river of Tison (Colorado River). Escalante had sent additional letters to other clergy proposing an expedition to find the lost Spanish colony, indicating that he had a strong ulterior motive for his journey to the northern frontier and search for a route to Monterey. Escalante may have believed he would find the lost Spaniards when he crossed the Río del Tizón on his expedition to California.

If the floor were still exposed to the elements at that time, Escalante may have gathered information from Rivera's expedition in 1765, which came back with stories of Spaniards and men in metal suits and hats living

across the Colorado River. Additional information may have come from non-entrada Spanish traders who illegally traded with the Utes. The Utes were a great source of information about the geography of the northern frontier. Escalante would have naturally believed a large man-made floor in the mountains as evidence of a lost Spanish colony. The Utes were familiar with European-style buildings and stone floors because of their trading trips to Spanish towns such as Santa Fe. Escalante, as evidenced by his letters, had an intense interest in finding proof of a lost Spanish colony, and this might be the reason why the Dominquez and Escalante expedition suddenly veered off course and headed northeast over the mountains to examine the mysterious floor. Escalante's willingness to divert from a relatively easy trek on flat ground and undertake an arduous mountain journey to see the floor reinforced Bailey's notion that Spanish explorers would often go to any length to seek out the validity of their legends and myths. Don Bernardo de Miera y Pacheco's map of 1779 revealed the arduous route over the mountains and the September 4, 1776 campsite named Santa Rosalia very close to the floor location. The Spanish colonial government was very territorial and sensitive to stories about possible Europeans in the area, especially the French. Escalante would have probably excluded his discovery of the floor site from his diary to avoid official dismay at his actions or to secretly report on it when he returned to Santa Fe.

Escalante's letters written after his return from the expedition never mentioned finding any trace of a lost Spanish colony. On April 2, 1778, Escalante wrote Father Juan Agustín Morfi a letter that reiterated his theory that the "Spaniards" living across the Río del Tizón were the bearded natives he met on his expedition in 1776. Bailey was still surprised the Collbran mystery floor location was so close to Dominquez and Escalante's Santa Rosalia campsite. The explorers had taken a difficult, mountainous diversion from their course to travel to this location. However, he had no conclusive evidence they had visited the floor or that it was exposed to the elements at that time.

On March 27, 2017, ten years after Bailey's initial search for information on the floor, he was searching the Library of Congress's online historical map collection for early maps of Colorado and found a map draw by Father Silvestre Veléz Escalante in 1777. Bailey had looked at the 1778 map by Dominguez and Escalante's expedition cartographer, Don Bernardo de Miera y Pacheco, which documented their journey, their campsites and the previous unknown topography of the northern frontier. Pacheco's map legend of 1778 depicted two bearded Native American men and

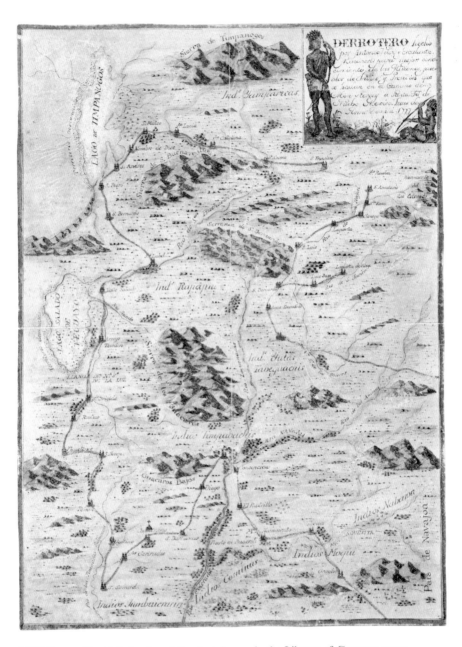

WIT director David Bailey found Escalante's map in the Library of Congress maps collection. *Museums of Western Colorado.*

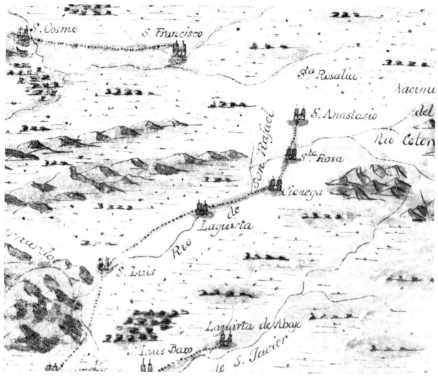

Above: On Escalante's 1777 map, his travels were carefully marked by dots except in the area before and after the Santa Rosalia campsite. *Museums of Western Colorado.*

Left: Escalante's map legend shows two Native American men, one standing and one sitting, on a bright-yellow stone floor. Note the drawn-in edge of the floor between the two figures. *Museums of Western Colorado.*

two women with a fishing net. The significance of this drawing was not lost on Bailey, who knew one of Escalante's main reasons for going on the expedition was to solve the mystery of the lost Spaniards and their colony. Escalante discovered that the "lost Spaniards" were Native Americans with long beards that resembled Spanish frontiersmen. The 1777 map, drawn with pen and ink and watercolors, was like Pacheco's map and showed little dots connected with a red line on the map that marked their journey and their various campsites. However, on Escalante's map, the red dotted line stopped abruptly at the Santa Anastasio campsite. Escalante's red dotted line starts again at the Santa Francisco campsite, and the Santa Rosalia campsite, close to the floor site, is in an unmarked area between the two camps. Bailey questioned why Escalante would carefully chart his 1,700-mile journey and leave out this section out of his map. Bailey looked at the map legend again and translated it from Spanish to English: "Course made by Antonio Velez de Escalante, missionary, for the better knowledge of missions, Indians and presidios [forts] that are on the path to Monterrey from Santa Fe, New Mexico. Year of our Lord 1777." Escalante's map legend was placed directly above the floor's location on the map. Bailey then studied the drawing in the map legend and found his answer: two Native American men, one standing and one sitting, on a bright yellow stone floor.

A TALE OF TWO BATTLE AXES

In July 2006, WIT science coordinator Dr. Rick Dujay conducted metallurgic testing on a Spanish colonial bridle bit and spur from the Museums of Western Colorado's collection at the Mesa State Electron Microscopy Lab. The Western Investigations Team was interested in creating a database of Spanish colonial metallic artifacts found in western Colorado. The test results from the objects would create a metallurgic profile of how and when these Spanish colonial artifacts were created. This would provide comparative data when identifying other artifacts from the Spanish colonial period, some which are stored at other Colorado museums or found during recent archaeological excavations.

In September 2007, WIT director David Bailey and Dujay traveled to Meeker, Colorado, to pick up two Spanish-style halberds displayed at the White River Museum. The Spanish colonial halberd was as a long-pole infantry weapon used by early Spanish soldiers and explorers and became a standard weapon of Spanish infantrymen. Halberds usually had three parts that made up the metal head attached to the pole. There was an axe blade for slicing, a spike for thrusting, and a hook for pulling an armed opponent off his horse. The infantryman essentially had three weapons in one. One of the many variations of the halberd was with a wider axe face and a longer spear point. The halberd began to lose its effectiveness with the introduction of firearms.

David Steinman, a White River Museum board member and historian, contacted Bailey when he read about the discovery of Spanish artifacts by

the Western Investigations Team in the Kannah Creek valley south of Grand Junction. Steinman asked Bailey and Dujay to test halberds that had been on display at his museum for last ten years. One was found at the Meeker Incident Site, where Indian agent Nathan Meeker had been killed by Ute Indians in 1879, and the other was found twenty miles from the town of Meeker. Steinman theorized the halberds might have been left by the Utes, who might have acquired them from Spanish traders.

After returning to the Mesa State Electron Microscopy Lab, Dujay tested the halberds and dated them from the late seventeenth century to the early nineteenth century because of the metallurgic impurities in the forging process. Bailey also began to look for historical references to the blade type and design of these halberds. The smaller of the two halberds had an unusual axe face that was curved on the edges and flat in the middle section. Bailey thought it might date to a time after the Spanish colonial period, because the blade was held in place by a cast-iron shaft that would be too brittle for warfare and would shatter on contact with a hard surface such as armor or a shield. He consulted Carl P. Russell's book *Firearms, Traps & Tools of the Mountain Men*. In the chapter entitled "The Axe on the American Frontier," Bailey found a picture of a blade identical to the Meeker halberd, with a flat middle section and curved edges. It was discovered by archaeologist Samuel

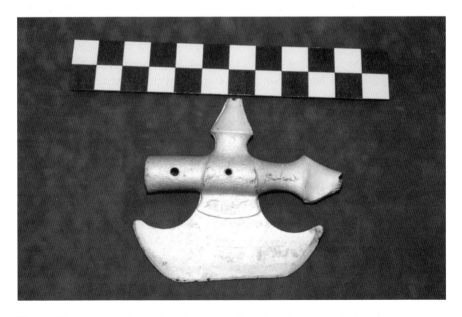

The smaller of the two halberds had an unusual axe face that was curved on the edges and flat in the middle section. *Museums of Western Colorado.*

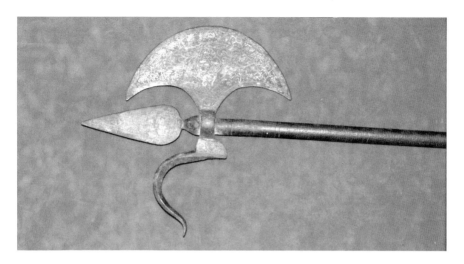

The larger halberd was beautifully incised with Arabic scrollwork. *Museums of Western Colorado.*

Dorris Dickinson at the Caddo Site in Arkansas in 1927 and was believed to be a Spanish colonial halberd. However, many years later, National Park Service employee Charlie Steen and officials from the American Tobacco Company confirmed it was a nineteenth-century blade from a battle-axe tobacco cutter used to cut plug tobacco. The top point of the blade had a hinge, and the halberd had a short wooden handle that allowed the operator to chop plug tobacco. The tobacco cutter was manufactured by Rogers Iron Company in Springfield, Ohio, and was a promotional item for the Battle Axe Tobacco Company.

The second Spanish-style halberd has beautiful Arabic scrollwork, a wide blade, a lance point and a hook. It would seem to any Southwest historian that an Arabic halberd on the western frontier of Colorado would be out of place. However, early on, these exotic blades were imported for the Native American trade. These blades, known as Persian blades, have been discovered within Native American collections, and one is cited in Carl P. Russell's book, which mentions a Persian blade with a Native American snakeskin-buckskin cover over a wooden handle. Interestingly, the halberd that looked "authentic" was actually a nineteenth-century tobacco cutter, and the Arabian halberd was actually used by the Ute Indians. This reminded Bailey that museum artifacts categorized to a specific period or overlooked because of their exotic nature can ultimately add a completely different and fascinating history to the story of the American West.

AZTEC TALES AND UTE MYSTERIES

A Cultural Bond across the Centuries

Western Investigations Team director David Bailey is also the curator of history at the Museum of the West (a division of the Museums of Western Colorado). Museum visitors often ask Bailey why there are so many Aztec treasure tales that focus on western Colorado and eastern Utah, when Mexico City is nearly two thousand miles to the south. Bailey explains to museum visitors that the Aztec treasure stories might originate from treasure hunters who knew that the Utes and Aztecs spoke a similar language hundreds of years ago. Treasure hunters are known for their highly speculative stories concerning the ancient Aztecs burying treasure in western Colorado or Eastern Utah. Bailey knew the Utes and the Aztecs had a linguistic connection but little else about their joint tribal histories. He decided it would be valuable to the Western Investigations Team's future investigations that dealt with Native American mysteries to research the connection between the Ute Indians of western Colorado and the Aztec culture. He found extensive scholarly research on their shared linguistic roots, known as the Uto-Aztecan language.

During his research, he found an early reference connecting the Ute and Aztec languages in Fray Gerónimo Zárate Salmerón's account of the Don Juan de Oñate's 1604 expedition to California. Spanish captain Gerónimo Márquez and four soldiers met with a group of Amacavas (Mohave) Indians. The Amacavas told them about the Lake of Copalla, the legendary homeland of the Aztecs. One of the Mohave Indians heard an Aztec servant of a Spanish soldier talking and asked if he was from the Lake of Copalla. He

said the inhabitants of Copalla spoke the same language as the servant. Many scholars today think the legendary Lake of Copalla is the Great Salt Lake in Utah. Large groups of Ute, Paiute and Shoshone Indians lived near the Great Salt Lake and spoke different dialects the Uto-Aztecan language. The Mohave Indian detected similarities between the Aztec servant's language and the Uto-Aztecan speakers around the Great Salt Lake region. The Aztec native tongue is called Nahuatl and is part of the larger Uto-Aztecan language group still spoken by many tribal groups north of Central Mexico. Uto-Aztecan speakers have northern and southern linguistic branches. The northern branch includes the Utes, Paiutes, Shoshones, Comanches, Hopis and many other native cultures. Bailey found it interesting that modern language scholars believe the Aztecs' Uto-Aztecan linguistic homeland was located in the Southwestern United States. This might explain the numerous Aztec treasure legends and lore that permeates the Southwest. Bailey speculated that the Utes and the Aztecs had more in common than just a root language; perhaps there were similarities in their customs and legends. Bailey traveled to Montrose, Colorado, and interviewed Roland McCook, former tribal chairman of the Northern Utes and great-great-grandson of

Roland McCook, former tribal chairman of the Northern Utes, on horseback. *Museums of Western Colorado.*

the famous Ute leader Chief Ouray and Chipeta. McCook recalls asking the elders about their ancient kin, the Aztecs. He remembers:

My people referred to these people as "moqui-ch," or just as old people "wee-nuche-ew." I have heard the definition for moqui-ch as people who live in the earth, such as caves, or one that is the meaning of the word moqui, which is to fall head first into the ground; perhaps this is another way of saying that they live in the ground or cave. Another name was "Cuma-nuche-ew," meaning other people, usually meaning people from somewhere else and not of our people or people who are gone.

Bailey conducted extensive research on Aztec and Ute creation stories to discern if there were similarities in their narratives. He found the passage about the Utes' ancient kin living in the ground or a cave interesting, because the Aztecs had a similar story. The Aztec creation story tells of seven Nahuatl-speaking tribes emerging out of a lifeway passage from a seven-chambered

Ute basket (*opposite*) compared to Chicomoztoc (*left*), the place of emergence of the Aztec tribes. *Both, Museums of Western Colorado.*

cave in a place called Chicomoztoc. The Aztec place of emergence is topped with mountains surrounded by the earth. Bailey looked at an image of the Aztec Chicomoztoc and noted it was very similar to the design Utes used in wedding baskets they traded to the Navajos. The baskets, often with seven interior lobes, have black triangular elements that represent rain clouds and mountains, a red band representing the sun and the basket itself symbolizing the earth. The center of the basket is the place of emergence from which the people came to the surface. They had to follow a mythological pathway from the center of the basket to the rim.

Bailey conducted extensive research and found similar folklore shared by the distant Uto-Aztecan cultures. The Northern Utes tell an ancient tale of emerging from the great waters where men had the bodies of fish. The Aztecs believe that during the fourth age of man, the world was covered with

water and men became fish. Both tales end with men taking human form and walking on the earth again. The Aztec and Ute cultures viewed the land and the human spirit as inseparable. The Utes believed separation from sacred lands was a form of spiritual death. The Aztecs believed the earth was the center of sacredness and the forces of nature were holy and provided life. The Utes of present-day western Colorado had many mythological stories that focused on Grand Mesa, one of the largest flattop mountains in the world, with twin promontories that dominate the skyline of western Colorado's high desert. He found that duality is a reoccurring theme in both Ute and Aztec mythology. The Ute creation story, which has many variations, tells the story of Sinavav, the creator, who represents balance and harmony, and his opposite Coyote, the trickster, who at times represents chaos and disorder in the world. Sinavav cut up sticks and put them in a bag and tied it shut. While Sinavav was away, the ever-curious Coyote opened the bag, and out jumped many people speaking different languages. Soon they started fighting for control of the land. The Ute people stayed in the bag, and Sinavav thought they were very brave and would defeat the other warring people. The Aztec culture also had opposite entities, Huitzilopochtli, the sun, fire and war god, and Tlaloc, who produced lightning and with it life-giving rains. The two Aztec gods were expressed in a combined symbol, Atl-tlacinolli, or fire and water. Amazingly, the outline of Grand Mesa is the mirror image of the ancient Atl-tlacinolli glyph. The symbol had many meanings in Aztec legend and mythology. The combination of the two symbols, fire and water, was sometimes broken in two to denote just water, fire or a location on a map. The ancient Aztecs often used paired symbols to refer metaphorically to a single concept; fire and water were bound together as opposites and would continually battle each other. The two gods had side-by-side shrines on the Great Temple, a double pyramid in the Aztec capital. The Aztecs said the dual pyramids represented a real mountain that had twin promontories.

Perhaps Grand Mesa's twin promontories had a special meaning to the Uto-Aztecan peoples, and this would account for the many legends associated with Grand Mesa. Bailey speculated that the entire Atl-tlacinolli symbol, whose outline matches the shape of Grand Mesa, might represent the mountain as a sacred site during the Uto-Aztecan migration from the north to ancient Mexico.

Bailey's research found numerous connections in the Aztec and Ute mythologies, but he was most intrigued by a mythological story about an eagle and serpent in both cultures and the connection between a small Aztec temple found in Malinalco, Mexico, and the Thunderbird legend of

The outline of Grand Mesa (*below*) is the mirrored image of the ancient Atl-tlacinolli glyph (*left*). *Both, Museums of Western Colorado.*

The inner sanctum of the temple in Malinalco, Mexico. The jaguar pelt at the bottom of the curved bench is flanked by two eagles. The eagle on the floor is facing the serpent-mouth opening. *Illustration by Rick Adleman, Adleman Fine Art and Illustrations.*

Grand Mesa. Bailey found the temple site during his study of Aztec myths and legends. The Malinalco temple is 1,865 miles from western Colorado's Grand Mesa. Construction began in 1501, after the Aztec journey from their northern homeland, Aztlán, some forty years earlier. It was one of the last Aztec temples constructed before the Spanish Conquest in 1521. The majestic Whitewater Basin in western Colorado and the small Aztec temple 70 miles south of Mexico City share a cultural mystery that transcends distance and time. Perhaps the Uto-Aztecan creation tale associated with both sites was passed down by the common mythology that once tied the two tribal groups together by language and tradition.

The eagle and serpent had deep significance in Aztec religious beliefs. The Aztecs were weary of their long migration south from their homeland and looked for a sign of the promised land. Their god Huitzilopochtli gave his priests a vision that they would find an eagle devouring a serpent on top of a cactus. The next day, the priests saw the eagle on the cactus with a serpent in his talons and founded Tenochtitlán, the Aztec capital (present-day Mexico City).

The Aztec eagle-and-serpent story is carved in stone at the temple in present-day Malinalco, Mexico. The main temple is called Cuauhcalli, meaning "house of eagles." It is one of the few examples of a nearly intact Aztec structure that survived the Spanish Conquest. The temple is carved into a mountain to create an artificial cave. Carved on the outside of the cave face is a large serpent with fangs on both sides of the opening. On the floor in front of the opening is the bifid (split in two) carved tongue of the serpent. The inside of the cave is a circular room with a raised curved ledge on the back wall. Two carved eagles sit on the curved ledge with a flat jaguar pelt between them. Jaguar pelts in Mesoamerican mythology usually represent a cave or the center of the mountain. Jaguars, by their nature, live in caves and hunt at night. On the floor, as if being swallowed by the serpent, is another eagle. Mexican scholars believe the cave inside the temple represents the womb of the earth. It represents Aztlán or Chicomoztoc. The Aztecs believed the eagle was a disguise of the sun and the terrestrial form of Huitzilopochtli. When Huitzilopochtli was to be born of the earth mother, Coatlicue (She of the Serpent Skirt), her sibling gods became angry and plotted to kill him. He burst forth fully grown, climbed up Coatepec (Snake Mountain) and defeated the immortals. In his earthly disguise as a great eagle, he killed those born of the snake goddess. The Aztec people came forth metaphorically from the womb of Coatlicue. Many Aztec scholars believe the Malinalco cave temple is a carved stone model of the ancient homeland that gave birth to the Aztec nation.

Bailey discovered a similar legend told by the Utes. The story occurred on Thunder Mountain, known today as Grand Mesa. The Ute legend is not carved into a stone temple but is preserved in Ute oral tradition. It takes place in a natural cathedral called Whitewater Basin. The basin is aptly named because of the white limestone plumes that cascade hundreds of feet down its sheer cliffs. Intriguingly, Aztlán means "Place of Whiteness."

The Ute legend identifies the white plumes as bird droppings and bones of animals consumed by giant mythical eagles (Thunderbirds) known as Boh'ooonii'ehii, who had their nests on top of the cliffs. The eagles perched on a large curved basalt-capped bench, like the carved curved bench in the Malinalco temple, on the north face of Whitewater Basin. The Ute leader Weasel Bear's son was taken from their village in Kannah Creek and killed and eaten by a giant Thunderbird. Weasel Bear in his anger scaled the Whitewater Basin cliff and, while the giant eagles were away, cast the young eaglets from their nests down the mountain. When the giant eagles returned, they were enraged because their young were gone. The great

Grand Mesa's large plumes of white limestone. *Museums of Western Colorado.*

serpent Batiqtuba lived below them near a small lake, known today as Cliff Lake. Batiqtuba had feasted on the young eagles as they fell from above. The great eagles suspected the serpent and swooped down, grabbed him in their talons and flew high above Grand Mesa.

The great eagles tore the serpent apart, and the pieces fell to earth and created large holes that would fill with water and become the lakes on Grand Mesa. The iconic scene of a great eagle clutching a serpent above Grand Mesa in Ute mythology is similar to the supernatural sign the Aztec priests were told would identify Aztecs' promised land where they would found their capital. That image is featured on the national flag of modern Mexico. The heroes in both stories climbed a mountain to take on supernatural beings. Bailey was captivated by the Malinalco temple, which showed two carved eagles perched on a ledge and another on the floor metaphorically being swallowed by the serpent carved on the opening of the temple, mirroring the Ute story of the eagles (Thunderbirds) on Grand Mesa.

Bailey's extensive research connected the Aztec and Ute cultures, separated by nearly two thousand miles and apart for hundreds of years, who shared so much of their ancient culture and mythologies.

AN ANCIENT JOURNEY TO COLORADO

One of the great legends and enduring mysteries of the West is the location of Aztlán, the Aztecs' original homeland, supposedly located somewhere in the present-day Southwestern United States. For hundreds of years, Spanish conquistadors, explorers, treasure hunters, anthropologists and historians have searched in vain for its location. There are many stories and legends that put the Aztec homeland in Arizona, Utah, New Mexico and western Colorado. The Aztec emperor Montezuma told Spanish conquistador Hernan Cortés that he and his people were originally not from Mexico but from a distant land. Montezuma was relating a tale he had known since childhood. David Bailey believed the clue to Aztlán's location would be found through researching the remaining Aztec and European histories, which could contain an accurate description of the geography and topography of the ancient homeland. Bailey found creation stories that told of the Aztecs' emergence from seven caves and their migration from a northern land called Aztlán (Place of Whiteness). However, the Aztecs' pictorial books, known as codices, had over twenty different accounts of the migration from the northern lands to Mexico. One tradition stated the Aztecs left Aztlán on their calendar date of 1 Flint Knife (AD 1111). According to legend, they were led by Huitzilopochtli, who commanded them to leave for the promised land to the south. Bailey did find a vague description of Aztlán as a place of many lakes and lush foliage and full of fish and waterfowl. It was described as an island unto itself surrounded by arid, inhospitable lands. The Aztec migration was a

long, hard journey in which they would stop for intervals, build temples and wait for years for instructions from Huitzilopochtli. They eventually arrived at their destination in present-day Central Mexico in 1 Flint (AD 1376). The Aztecs, who called themselves the Mexica, would forever long for their beautiful ancient homeland. The general description of Aztlán was not definitive enough to pinpoint a location, because it described hundreds of possible sites in the Southwest.

Bailey discovered that Aztec histories were very scarce, because most of their cultural and historic records had been destroyed. The Aztecs and neighboring kingdoms, like the Mixtecs, created thousands of codices that recorded history, migration legends, poetry, astronomy, medical treatments, botany and many other important topics. Perhaps they also contained more detailed descriptions of Aztlán and its location. After the Spanish conquest of the Aztec Empire, thousands of Aztec codices were burned by Catholic priests, who believed the works were all native superstition. However, a few priests recognized the cultural value of the codices and saved a few screen-fold books. Only fifteen pre-Columbian codices survived the Spanish Conquest. The screen-fold books were made from pounded bark paper or deer hide that was painted on each side with white lime gesso. The painter/scribe could then paint glyphs on each side. The painted pages were folded and stored accordion-style in a protective deerskin cover or bound with wood covers.

The Aztec scholars told their history to Spanish priests through their remaining oral tradition. Upon their arrival in Mexico, the Aztecs lived a simple existence as hunters and gatherers, occasionally supplementing their diet with subsistence agriculture. They described themselves in that time as wearing animal furs and hunting with bows and arrows. Upon entering present-day Mexico in AD 1326, they were called by other, more civilized city-states the Chichimec, which translates as "linage of the dog." The Aztecs quickly rose to power as mercenary fighters for powerful city-state rulers. The great Toltec civilization had collapsed by AD 1168, and the ruins of its great temples were admired by the Aztecs. The Aztecs looked at the former Toltec capital, Tula (Hidalgo, Mexico), which once had a population of thirty thousand, with wonder and awe. The militaristic Toltecs had developed a very advanced civilization that included masonry temples, wide paved avenues, skilled craftsmen, warrior clans and a sophisticated religion. The Aztecs adopted the Toltec Empire as a prototype for their new civilization. From the remaining Toltecs, they learned art, astronomy, engineering, governance and military organization

and tactics. With this new knowledge and their fierce fighting abilities, they soon dominated the entire region.

Bailey found through his research that the Toltec Empire (900–1168) and later the Aztec rulers (1427–1521) created vast trade networks that reached as far as the Colorado Plateau. The plateau has been occupied by people for the last ten thousand years. The Chaco Canyon Culture (AD 900–1150) had a vast center for regional trade goods such as corn, squash, beans and textiles. It built massive, multistory buildings known as "great houses" that contained hundreds of rooms. The Chacoans also traded for exotic non-utilitarian items from Mesoamerica, such as Baja and Pacific Coast shells and copper bells. The trade to the Colorado Plateau made the Mesoamerican leaders aware of the vast inhabited area to the north. They were particularly interested in the mineral trade. The trade route between Mexico and Chaco Canyon has become known as the "Turquoise Road" because of the large quantity of turquoise traded to Mexico. Scientists using neutron activation analysis have found that some of the turquoise used in mosaics in Mexico was from the Cerrillos mines, west of Santa Fe, New Mexico. In return, the Mesoamerican people sent highly prized scarlet macaws and parrots to the Chacoans. Their feathers were probably used for rituals and ceremonial costumes for the Chacoan elite. The trade routes provided more than just commerce; they also brought new knowledge, legends and myths of great cities and riches that probably tantalized the traders from both distant lands. This made Bailey wonder if the Aztec homeland might truly be in or near the Colorado Plateau, which encompasses most of present-day western Colorado and parts of Utah, Arizona and New Mexico.

Although most of the Aztec codices had been destroyed, Bailey found there were dedicated Catholic priests who preserved the Aztec history by interviewing and recording stories from native scholars and scribes who remained after the destruction of the Aztec Empire. Diego Durán was brought to New Spain a small child and grew up in the former Aztec city Texcoco. Durán learned to speak Nahuatl, the Aztec language, and at a young age became very interested in his new land. He joined the Dominican Order in 1556 and was assigned the task of studying the customs and religion of the Aztecs to convert them to Catholicism. He developed a deep admiration for the people and their culture. Fray Durán studied native manuscripts and interviewed elders to learn their unique history. His famous accounts of Aztec history was entitled *The History of the Indies of New Spain*. Although it was written in 1585, it was not published until the nineteenth century.

At long last, Bailey had found a great geographical description of Aztlán. Fray Durán tells the story of Montezuma the Elder's desire to find his people's ancient homeland. His grandson, also named Montezuma, was held hostage and killed during the Spanish Conquest. Montezuma the Elder was the fifth emperor of the Aztecs, ruling from 1440 until 1469. He was one of the most capable emperors, and under his rule, the Aztecs reached their greatest military strength. He felt his people were respected and feared by other nearby kingdoms because of their battle prowess and strong alliances. Durán's book relates that Montezuma the Elder believed he ruled by divine right and felt the need to invigorate the noble lineage of the Aztec people. By command of the emperor, the Aztec subjects were taught the history of the great migration from their beloved homeland, Aztlán, to the promised land. He called together the wise men of the empire to help discover more about their past. Montezuma the Elder suggested to Tlacaelel, his prime minister, that soldiers be sent north to look for Aztlán, but Tlacaelel disagreed and stated,

> *You must know, O great Lord, that what you have determined to do is not*
> *for strong or valiant men,*
> *Nor does it depend upon skill in the use of arms in warfare.*
> *Your envoys will not go as conquerors, but as explorers;*
> *They will seek out the place where our ancestors lived,*
> *They will try to find the place where our god Huitzilopochtli was born.*
> *Montezuma the Elder agreed with this council and sent for the royal historian,*
> *An elderly man named Cuauhcoatl, "Eagle Serpent," and asked him*
> *"O ancient father, I desire to know the true story,*
> *The knowledge that is hidden in your books*
> *About the seven caves from which our ancestors came forth*
> *Our fathers and grandfathers*
> *I wish to know about the place wherein dwelt*
> *Our god Huitzilopochtli and out of which he led our forefathers."*

Cuauhcoatl told them about the blissful place called Aztlán, which means "Place of Whiteness," and described the important landmarks, flora and fauna and difficult areas of passage. In the 1440s, Montezuma the Elder did indeed send scholars instead of soldiers on the journey north to find Aztlán. After many months and a difficult and treacherous trek, the explorers returned and claimed to have found their ancient homeland. Bailey knew that in ancient times, the Aztecs' ancestors had been to the north to trade, but how was it possible for the Aztecs to find their way to Aztlán after the passage of hundreds

of years? They were exacting mapmakers and precise architects of sacred temples and pyramids. Their religious buildings had order and symmetry and were aligned for important astronomical events. On the journey north looking for their homeland, the Aztec explorers may have passed the ruins of the great houses, the former centers of a vast prehistoric trading network with the Mesoamerican empires. Many of the great houses were roughly on a north–south alignment from Paquimé (in present-day Northern Mexico), which was still active in the 1440s, to Chaco Canyon and farther north to the Aztec Ruins (both in present-day New Mexico). This uncanny alignment was written about by University of Colorado archaeologist Stephen Lekson in his book *The Chaco Meridian: Centers of Political Power in the Ancient Southwest.* It is possible that the Aztec explorers may have questioned the residents of Paquimé about this alignment and its significance.

Bailey believed it was logical to surmise that Aztec explorers might have followed the aligned great houses to the north in an effort to find their homeland. If Montezuma the Elder's expedition went north to each great house site and past the Aztec Ruins (a prehistoric Anasazi great house misnamed in the nineteenth century), it would have entered the land of the Aztecs' distant cousins the Ute people. The unusual alignment then continues to Grand Mesa in western Colorado.

In Diego Durán's *History of the Indies of New Spain*, Montezuma's royal historian, Cuauhcoatl, recorded this description of the ancient Aztec homeland, Aztlán:

> *Our forebears dwelt in that blissful, happy place called Aztlán, which means "Whiteness"....On its slopes were caves or grottos where our fathers and grandfathers lived for many years. There they lived in leisure, when they were called Mexitin and Azteca. There they had at their disposal great flocks of ducks of different kinds, herons, waterfowl, and cranes. Our ancestors loved the song and melody of the little birds with red and yellow heads. They also possessed many kinds of large beautiful fish. They had the freshness of groves of trees along the edge of the waters. They had springs surrounded by willows, evergreens, and alders all of them tall and comely.*

Bailey felt Cuauhcoatl's description of Aztlán seemed to indicate foothills or slopes of a mountainous area where abundant rainfall could support diverse flora and fauna. The description matches the foothill and montane life zones, which range from six to ten thousand feet in altitude. He was particularly interested in Durán's passage, "Our ancestors loved the song and

A western tanager with its distinct red head. *Museums of Western Colorado.*

melody of the little birds with red and yellow heads." This description best fits the western tanager. These small birds are usually six to seven inches in length. The tanagers have a bright yellow body, and the male has a bright red face that is very rare in birds. The male tanager eats insects that acquire the pigment rhodoxanthin from plants. During the breeding season, the male tanager's head becomes a bright red that gradually fades as his insect diet diminishes. The birds usually breed in mountainous areas in Colorado and other northern states at eight to ten thousand feet. Bailey thought the Aztecs must have been at high altitude to see their favorite red-and-yellow-headed birds. Aztlán's description fit many areas in western Colorado, including Grand Mesa.

Montezuma the Elder sent his explorers north to find their ancient homeland, but had earlier Mesoamerican expeditions also visited the lands to the north? Scholars have speculated about visits from Mesoamerican cultures to the northern Southwest. Archaeologists have theorized that the trade between Central Mexico and the Southwest also brought information about the wealthy trading centers to the north, such as Chaco Canyon. Perhaps Mesoamerican warriors were sent north to test military strength as a prelude to conquest. The Toltecs had strong trade ties to the Southwest and were contemporaneous with the Chaco Canyon Culture and the Fremont Culture, which occupied the western Colorado Plateau and the eastern Great Basin.

Bailey found no historical or archaeological records to indicate a Mesoamerican military presence in the Southwest. However, there are hundreds of Fremont rock art sites that depict battle scenes in which warriors with shields take trophy heads of a vanquished people. Bailey photographed rock art at the McConkie Ranch, near Vernal, Utah, which has some of the most striking examples of early warfare. Many of the spectacular rock art panels are located near the archaeological remains of Fremont occupation sites. The rock art has dramatic images of warriors dressed in tunics with feathered headdresses holding their vanquished enemies' heads in their hands. Depictions of Toltec warriors from Mexican archaeological sites show them in short tunics and feathered headdresses and holding captives

Right: Rock art
warrior figure
with round
disk. *Museums of
Western Colorado.*

Below: The
Three Kings
rock art panel at
the McConkie
Ranch in Vernal,
Utah. *Museums of
Western Colorado.*

by the hair. A few archaeologists have suggested the heads in the warriors' heads are masks, but Bailey wondered why masks would be depicted with tears streaming from their eyes. It seems more likely that the tears were shed symbolically by a defeated warrior. It was a frequent practice in Mesoamerica for armies to take the heads of their defeated enemies as war trophies. Even more mysterious are the rock art figures with large disks on their backs. Mesoamerican armies were highly organized, and select troops wore colorful large round ornaments on their backs so the field commander could identify divisions and organize attacks. The warriors dressed in exotic uniforms that resembled eagles, jaguars and anthropomorphic beings. The warriors' costumes identified their status and struck fear into their enemies. Bailey wondered if Fremont rock art deemed anthropomorphic might actually depict what the Fremont people witnessed when they were attacked. What information besides legends and codices guided Montezuma the Elder's explorers on their fifteenth-century journey to Aztlán?

Another puzzling aspect of Fremont rock art is the numerous depictions of warriors with shields. Bailey had studied reports from Fremont archaeological sites and discovered no evidence that they used war shields; the two shields found at Fremont sites were later dated to the Plains Indian period. The rock art panel at the McConkie Ranch site known as the Three Kings shows the center warrior with a highly decorated shield that has straight pleated leather fringe at the bottom. This type of shield is not typical of North America but is a common element in Mesoamerican depictions.

Archaeologist David Wilcox proposed there was a prehistoric language exchange route across the Southwest and Mexico that he called the Tepiman Connection. The route was a string of geographic areas connected by a common language, Uto-Aztecan. Other archaeologists pointed out that Spanish colonial travelers often used the ancient established trails that linked Mexico to the Southwest. Bailey reasoned that Montezuma the Elder's scholars could have easily obtained information from Uto-Aztecan speakers in each area they traveled through on their way north. Durán's narrative states that Montezuma the Elder's explorers returned after a difficult and dangerous trip and claimed to have found their ancient homeland. Although Bailey found no historical commentaries or explicit archaeological proof that Montezuma the Elder's 1440s expedition made it to Aztlán, the alpine description of their ancient homeland and the description of the red-and-yellow birds is a tantalizing clue that could place Aztlán on or near the Colorado Plateau.

THE CAVE OF THE ANCIENTS

I n the spring of 2009, David Bailey was researching Ute legends on Grand Mesa when he found an old archival binder of pioneer histories and U.S. Forest Service letters at the Loyd Files Research Library at the Museums of Western Colorado. A 1942 Forest Service letter contained a story by early Grand Mesa historian and pioneer E.D. Stewart about the Ute Indians living there. Stewart related, "This was his home; the home of his forebearers for centuries. Tradition tells us of a great cavern, the Hall of Indian Fame, in Grand Mesa Mountain in which were held the councils and pow wows....Even after a diligent search it remains a mystery." The Ute cavern's description as the "Hall of Indian Fame" indicates it might contain items collected over a long period. If found, it might contain valuable prehistory and history of the Ute people. Perhaps the cavern contains rock art of hunters and warriors from different eras. Even more importantly, its discovery could shed light on the ancient Uto-Aztecan traditions that connected the Mesoamerican and Ute peoples.

The Western Investigations Team decided to investigate the legend of the Ute cave. Bailey contemplated the approach to finding the location of the cave among the miles of cliff face on Grand Mesa. He recalled his research on the Malinalco temple in Mexico. The Aztecs said the temple was a representation of their ancient homeland to the north. The Malinalco temple's carved stone eagles perched on the curved platform and the giant serpent swallowing an eagle told a similar legend to the Utes Indians' Whitewater Basin story: the giant eagles (Thunderbirds) nesting

on the curved cliff faces and the giant serpent hundreds of feet below that devoured the young eaglets. Bailey remembered that the other prominent carved figure in the center of the curved stone bench in the Malinalco temple was a jaguar. He recalled that in Aztec mythology, the jaguar was connected to caves. He decided to research further meanings of the carved jaguar. In Mary Miller and Karl Taube's book *The Gods and Symbols of Ancient Mexico and the Maya*, the jaguar god Tepeyollotl represented the heart of the mountain and lived in caves. Perhaps the Malinalco temple, which repeated the legends of the Thunderbirds in Whitewater Basin, also recorded, in the form of a stone jaguar, the location of a cave. Bailey and the WIT crew narrowed their search for the cave to the Whitewater Basin area of Grand Mesa, the main source the Uto-Aztecan legends. The team felt that since the top of Grand Mesa was flat, a passage from the top probably led down to a cave opening in the cliff face. The WIT crew spent several months searching the Whitewater Basin's cliff faces with high-powered optics to find a possible cavern site.

In early August 2009, museum director Mike Perry and David Bailey located a large, dark alcove in the cliff face that was a possible candidate for the location of the Ute cavern. Several days later, Rick Dujay and David

Large alcove in the cliff face of Whitewater Basin, Grand Mesa. *Museums of Western Colorado.*

Bailey followed an old road along the ten-thousand-foot rim of Grand Mesa to get closer to the potential cave location. They photographed the area around Whitewater Creek Falls and took a GPS reading to find the distance from the possible cave site.

In late August 2009, Dr. Dujay, Perry and Bailey decided to hike to the area above the large alcove and look for a possible passage from the top down to the site. Accompanying them were *Grand Junction Daily Sentinel* reporter Gary Harmon and photographer Chris Tomlinson. The *Daily Sentinel* had been following the story of the Ute cave and other WIT projects since 2005. The group discovered a narrow passageway like a small canyon on top of the mesa that led down inside the cliff face. There was evidence of rock slabs that were stacked over the top of the hidden passage. When Bailey returned from the site, he realized he would need a better method for examining the cliff faces from the top. Having search teams rappel down would be costly and very time consuming. The Whitewater Basin covered a large area and would be difficult to search with rappelling crews.

He eventually came up with a solution by creating a device dubbed Argos1. The device had a long wooden boom with a pulley system, enabling a high-definition digital video camera to be lowered down the eighty-foot sheer cliffs in the Whitewater Basin. The boom allowed the video camera to have adequate distance from the cliff face and avoid entanglements with brush and jagged rock outcrops.

The narrow passageway that led down into the cliff face. *Museums of Western Colorado.*

The extensive cliff face of Whitewater Basin, Grand Mesa. *Museums of Western Colorado.*

On September 25, 2010, Dr. Dujay, Bailey and a group of WIT student interns hiked a half-mile with the disassembled boom and equipment to the area and lowered the camera. The camera recorded the large opening found during the initial survey in 2009. The team discovered that the narrow passage led down to a massive area of the cliff face that had sheared off and fallen hundreds of feet below to the basin floor. It is possible the destroyed pathway originally led to a large grotto or cave, perhaps the so-called Hall of Indian Fame, now lost to history. Additional photographs from the rim adjacent to the grotto confirmed that a large section of the cliff face and trail section had sloughed off and fallen below. After Bailey and the WIT crew reviewed the video, it was discovered that the cavern opening was a small grotto with a solid stone back wall. The WIT crew found no evidence of a Ute cave or answers about early Ute history.

Bailey thought about the significance of the grotto. When the Aztecs talked about the natural features of their ancient homeland, Aztlán, it contained more than just caves. He remembered a passage describing their land from Diego Durán's *History of the Indies of New Spain*: "On its slopes were caves or grottoes where our fathers and grandfathers lived for many years."

Perhaps the Ute cavern was a large grotto destroyed by a massive rock slide. Or perhaps it was just part of the ancient mythology of Grand Mesa.

GEORGE CRAWFORD'S SECRET SAFE

To help celebrate Mesa County, Colorado's 125th anniversary (1883–2008), David Bailey choose two historical cases involving Mesa County and Grand Junction founder George Addison Crawford. The first case involved finding the location of George Crawford's secret safe, buried in a parking lot in downtown Grand Junction, and the second involved finding Crawford's lost ranch house site above the town of Palisade in Rapid Creek, Colorado.

George Addison Crawford was born in Clinton County, Pennsylvania, on July 27, 1827. He struggled with poor health as a youth and had to leave Jefferson College. He was determined to graduate, kept up with his studies at home and finally returned and finished at the top of his class in 1847. He then studied law at the offices of Allison & Quigley in Pennsylvania, and in 1850, he became editor and proprietor of the *Clinton Democrat* newspaper. Crawford's first aspirations as a town builder started in 1856 at the firm of Dillon, Jackson and Company, which contracted to build a railroad from Superior City, Wisconsin, to Hudson, Wisconsin. The firm had to cut through sixty miles of dense forest and deep snow to complete the job on time.

Crawford then headed west to Kansas and helped develop the abandoned military post Fort Scott into a town site. He bought claims to 520 acres with his business associates and started the Fort Scott Town Company. He became an active member in Kansas politics and was elected governor in 1861. However, the election results were declared illegal by legislators

George Crawford, founder of Grand Junction, Colorado. *Museums of Western Colorado.*

due to a misinterpretation of the Kansas Constitution, and he never ran for public office again. George Crawford headed to Colorado and started the Grand Junction Town Company on land near the junction of the Gunnison and Grand (Colorado) Rivers. He founded Grand Junction in 1881 and lobbied the Colorado state legislature to form Mesa County in 1883.

Bailey had a long history with George A. Crawford's mystery safe, which many residents of Grand Junction believed was an urban legend. While completing his senior year at Mesa State College (known today as Colorado Mesa University) in 1987, he wrote an economic history of the Schiesswohl Building, located at the corner of Sixth Street and Colorado Avenue in downtown Grand Junction. The building was completed in 1908 and was owned by Jacob Schiesswohl, an early businessman and real estate entrepreneur. Bailey's college paper chronicled the financial ups and downs of the building and how it mirrored the larger boom-and-bust cycle of Grand Junction and Mesa County. He had an inside track on the history of the building—his wife, Debbie, was Jacob's great-granddaughter, and her grandfather Ray had run the building since the 1920s.

In the fall of 1987, Ray Schiesswohl told Bailey the history of the building and its adjacent parking lot. He said in the early 1880s, George Crawford had a small cabin on the adjacent parking lot west of the Schiesswohl Building. In Crawford's time, Grand Junction was composed of canvas tents and a few cottonwood log cabins. One of those cottonwood cabins housed the office of the Grand Junction Town Company. Crawford's large number of real estate transactions necessitated a floor safe in the cabin, since the nearest bank was in Gunnison City, 125 miles away. The cabin was torn down when Dr. Alston P. Drew, a veterinarian, purchased the lot from the Grand Junction Town Company in 1908. Drew constructed a large veterinary hospital on the site and conducted business there until 1946, when he sold the lot to Ray Schiesswohl. Ray tore down the old veterinary hospital building to create more parking for the Schiesswohl Building. He needed the land to build his new gasoline service station, which was attached to the older building. Ray

hired Wallace "Boots" Corn, a local contractor, to flatten and grade the new parking lot. However, Corn's grader was stopped cold by an unmovable object buried in the center of the new parking lot. Ray and Wallace dug around it and were unable to dislodge it from the ground. Ray believed it must have been the safe from the old George Crawford cabin. They piled extra dirt on the obstruction and decided to grade over it. The new Schiesswohl Building parking lot was left with a high crown in the center that sloped down on each side.

In 1992, David Bailey became curator of history at the Museums of Western Colorado. He added the tale of George Crawford's secret safe to his downtown historical walking tours. For many years, he told the story of the lost safe to hundreds of schoolchildren and tour participants, and they all said the same thing: "Let's dig it up."

Finally, in 2008, it was time for the Western Investigations Team to honor the request. The City of Grand Junction was planning to conduct a major renovation of Colorado Avenue, with new curbing, parking lots and lighting. One of the areas scheduled for demolition was the Schiesswohl Building's old parking lot, under which were the remains of Crawford's old cabin and possibly his safe. WIT director David Bailey realized it might be difficult to locate the safe, because the parking lot covered a large area. He needed to improve his odds. Bailey contacted Dr. Larry Conyers at the University of Denver; Conyers was an international expert on the use of ground-penetrating radar (GPR) for archaeological applications and said he would send two students and equipment over to assist the WIT with the search.

On May 31, 2008, two anthropology graduate students from the University of Denver, Amy Hoffner and April Kamp-Whittaker, arrived with a GPR unit to survey the parking lot. They carefully laid out a grid with measuring tape to make sure they would cover the entire parking lot with the radar unit. The GPR unit was carefully pushed in an east–west direction over each gridded section of the parking lot. Hoffner indicated that the GPR detected large amounts of iron rebar in the parking lot. GPR radio waves were disrupted by cell phones, so she asked everyone at the site to turn them off to get a better signal. Hoffner and Kamp-Whittaker then went in a north–south direction over the same area and discovered a promising spot for the safe's location. They returned to the Museums of Western Colorado to download their data and print out the results. They explained to the WIT crew that GPR sends radio waves into the earth and measures the precise time it takes for them to be reflected

back to the unit. The area of interest took six to eight nanoseconds, indicating the object was buried approximately eighteen inches under the parking lot.

Bailey contacted Cliff Mays and Roy Catt with Mays Construction Specialties, which was undertaking the renovation of Colorado Avenue in downtown Grand Junction. He asked if they would lend the WIT crew a jackhammer and equipment to excavate at the possible site of Crawford's safe. They agreed to donate their time, personnel and equipment to the project. On June 27, 2008, the WIT crew began the excavation of the parking lot with a backhoe at the site marked by an X by the GPR team. The Museums of Western Colorado's curator of paleontology, John Foster, and curator of archaeology and anthropology, Zebulon Miracle, joined the WIT crew to assist with the excavation and preservation of artifacts recovered at the site. Archaeologist Phil Born, WIT scientific coordinator Rick Dujay and director David Bailey also assisted with the excavation and bagging and tagging of artifacts. The team carefully pulled aside debris looking for any remnant of George Crawford's cabin.

Immediately, they began bringing up buckets of dirt, old timber fragments, broken glass and ceramics, square-headed nails and a ten-inch layer of ash.

University of Denver's ground-penetrating radar crew surveying the parking lot. *Museums of Western Colorado.*

WIT director David Bailey at the ceramic opening of Crawford's cistern. *Museums of Western Colorado.*

Bailey believed this was probably the jumbled remnant of Crawford's cabin, which was burned down and graded over in the 1940s. He anticipated the safe would be in the debris field. The team uncovered sections of a slate floor and eventually uncovered a large old vertical salt-glazed clay pipe that was determined to be the top of a cistern (cisterns were used by pioneers to store water underground and reduce trips to a spring or, in this case, the Colorado River). The slate floor had originally been level with the top of the clay pipe. The WIT crew continued to search the area but found no trace of a safe or strongbox.

The cistern was a large, immovable object like Ray Schiesswohl's description of the safe. Bailey questioned if Ray thought the cistern was the safe? After Mays Construction Specialties filled in the excavated areas, Bailey returned to the museum to research the history of cisterns. He found that empty cisterns both small and large had been used to hide people and treasure for centuries. Residents of small coastal towns attacked by pirates would often hide their valuables in their cisterns. If cisterns had been used as safes, did this practice continue in the nineteenth century? In the 1850s, George Crawford lived in volatile pre–Civil War Kansas Territory, where proslavery and free-soil militias attacked towns and terrorized citizens. Bailey learned that it was a common practice for fearful residents to hide their money and valuables in cisterns to protect against looting militias. Perhaps Crawford left some old town records or even dumped them in the cistern after it was no longer in use. Ray may have found something in the cistern to make him believe that Crawford secretly stored items there and used it as a safe. It appeared the Western Investigations Team had solved the urban legend of George Crawford's secret safe: it was an old, dry cistern under the slate floor of Crawford's cabin, probably used to store town company records before it was filled in with dirt.

THE CRAWFORD RANCH

Former Home of the Palisade Pirates

I n the 1880s, George Crawford, Grand Junction and Mesa County's founder, had a beautiful ranch high above the town of Palisade. The ranch was a prosperous place with apple orchards, fields of hay, cattle and even a working coal mine. However, by the 1960s, no trace of the ranch house or ranch existed except for stacked-stone fences that encapsulated the now-barren 283 acres of land. In 2008, the Western Investigations Team decided to search for the location and possible remnants of Crawford's ranch house in honor of Mesa County's 125ᵗʰ anniversary. David Bailey searched through old land transaction documents and located two early photographs. The first showed a large group of people packing apples on August 30, 1896 (Crawford had died in 1891 and the ranch was managed by trustees). The second photograph was taken in 1905, after Crawford's ranch was purchased by Francis and Albert Bailey. In the photograph, the Baileys' brother William and another man are sitting on horseback in front of a large orchard. Mesa County assessor Barbara Brewer and her staff gave David Bailey detailed maps and other insightful documentation about the various owners of the property. He knew where the ranch itself was located, but there was no actual documentation of where the ranch house was on the property. Bailey decided to research some of the early owners of the ranch for any additional information on the location of the ranch house.

George Crawford owned the ranch until his death in 1891, and his historical files at the Museums of Western Colorado's Loyd Files Research

Library had no information on the ranch's location. After Crawford's death, his estate trustees put the ranch up for sale, and it was purchased by the Bailey brothers. David Bailey, in his role as curator of history at the Museums of Western Colorado, had researched and written extensively about the next owners of the Crawford ranch, Francis and Albert Bailey.

In 1897, Francis and Albert Bailey, two dapper gents from Pittsburgh, Pennsylvania, arrived in western Colorado. They promptly bought one of the area's largest ranches, the George Crawford place. Their brother William F. Bailey, an area resident and the Colorado Midland Railway ticket agent, had convinced his siblings to invest in the ranch and cash in on the agricultural boom in western Colorado. Albert was chosen to manage the ranch and soon became one of the most popular men in Mesa County. The *Grand Junction Daily Sentinel* described him as

> *a hail fellow well met everywhere and who went off on excursions, visiting friends and other cow men in the county, and had a pretty good time all around. He was often seen in the city* [Palisade], *and because of his charming ways, was always welcomed by a crowd of friends and acquaintances whenever he came to the city…a cultured gentleman and a man of travel.*

The newspaper also mentioned he was not a good cattleman, and a sizeable amount of money was lost during the Bailey brothers' ownership of the ranch.

Francis Bailey was the mastermind of the family's business ventures. Many of Bailey's get-rich-quick schemes failed, including investments at the 1904 St. Louis World's Fair and his dream to convert an ocean liner into a floating palace of American industry. The grand ocean liner, which never materialized, was supposed to sail to the world's ports and promote goods produced by U.S. manufacturers. The Crawford ranch was one of his many risky capital ventures. The Baileys had no experience running a ranch and were more suited to life as gentlemen on the Eastern Seaboard of the United States.

By 1908, Francis Bailey's business dealings had put him deep in debt, and he decided to carry out one of America's most colorful swindles. In July 1907, he sold the Crawford/Bailey ranch to Grand Junction businessmen A.R. and J.M. Sampliner for $15,000 to help settle his debts. Francis then called Albert back from his prosaic life as a gentleman cowboy in Colorado, and together they put their criminal plan into action.

The Baileys had one successful business, the Export Shipping Company of New York City. The company had a good reputation and was used by American manufacturers to ship goods overseas. In March 1908, the Baileys sent out orders to manufacturers across the United States for goods to be delivered to New York City for shipment to the General Supply Company of Australia. This included everything to start a colony: canvas tents, the latest firearms, a portable sawmill, china, food stores and every conceivable item to make life comfortable in the Outback of Australia. The goods were quickly delivered to the Export Shipping Company dock in Brooklyn and were valued at nearly $200,000. Albert and Francis also asked for bank drafts (checks) on the goods from each of the manufacturers so they could submit them to the Australian company's bank in London, England.

However, the Baileys' elaborate story of selling goods to Australia was a complete fabrication. Instead, they planned to take the goods and create a colony in Honduras, where they knew the United States had no extradition treaty. The General Supply Company did not exist, and they trusted the supplying manufacturers would not scrutinize a distant foreign business. They enlisted more conspirators, including H.H. Meyers, who posed as a businessman and consignee of the delivered merchandise, and Captain Albert Oxley, a former British citizen and sea captain. Taking the drafts from the manufacturers, they shopped around New York to foreign banks and cashed them in at a slight discount for nearly £100,000 (the most stable currency at that time). With their newfound wealth, they sent Captain Oxley to purchase a ship, the *Goldsboro*, and Oxley obtained British sailing papers by posing as a British citizen.

The Baileys quietly shipped out on May 2, 1908, flying the British flag, and as a diversion, they told the clerks at the Export Shipping Company they would be gone for several weeks to St. Louis. By May 15, their deception was uncovered. It was made public in the *New York Times*, which reported that the U.S. and British governments were pursuing the Baileys. Secret State Department telegrams indicated they were concerned about the shipment of guns, including the latest Model 1899 Savage rifles and special three-barrel guns (these were both a rifle and a double-barreled shotgun). The government believed the cargo was possibly meant for revolutionary purposes in South America. *Harper's Weekly* took wind of the story, calling the Baileys the new "Captain Kidds" of the twentieth century, and other newspapers gave numerous accounts of these modern-day pirates and their ship.

Meanwhile, the pirate ship *Goldsboro* arrived at Puerto Cortez, Honduras. A British consular officer intercepted the ship and made it take down the

British flag after he found out the Baileys had forged British shipping papers. The Baileys threw a huge banquet for Honduran officials at Puerto Cortez's finest hotel. The Honduran government gave them permission raised the Honduran flag on their pirate ship, and it was renamed the *Atlantida*. The Baileys did not like the scrutiny from the American and British consuls in Puerto Cortez, and the *Atlantida* set sail for La Ceiba. Once there, the Bailey brothers purchased the largest plantation in the area, La Fortuna, and began to unload their stolen booty. However, their bold act of larceny raised the ire of President Teddy Roosevelt, who brought out "the big stick." Roosevelt convinced Honduran president Miguel Davila to arrest the Baileys, even though the United States had no extradition treaty with Honduras. He sent an unofficial presidential warrant to leverage the Honduran authorities into arresting the Baileys and their coconspirators. The document held no diplomatic or legal weight and was sent with Peter W. Berry, a New York policeman.

In June 1908, a Honduran gunboat engaged the *Atlantida* at La Ceiba and took the Baileys and their coconspirators prisoners. Francis Bailey later stated that his pirate ship was heavily armed, and his crew could have defeated the gunboat and escaped. The prisoners were taken back to Puerto Cortez to await extradition. The intrigue was not over—as the Baileys waited in jail, they developed a powerful ally in Policarpo Bonilla, a former Honduran president and renowned lawyer. Secretly translated Spanish documents later revealed that Bonilla had acquired the Baileys' guns for revolutionary purposes.

While they waited for extradition, a revolution began against President Davila, and the State Department feared that the Baileys would be released. Peter Berry arrived with his presidential warrant but soon fell under the spell of the Bailey brothers' charm. He gave the Baileys access to their ship supposedly to gather personal belongings while accompanied by Honduran guards. Once on the *Atlantida*, the Baileys accessed a secret compartment full of British pounds near their cabin while the guards waited on deck. The money was to be used later to bribe Honduran government officials and make their escape.

The U.S. consulate in Honduras was worried about Berry, because he was careless with the prisoners. The consular officials made sure the Baileys were put on a Norwegian freighter, *Ulstein*, for prompt passage back to the United States. Berry was conveniently below decks when Francis Bailey escaped from the ship, leaving Albert, who was sick with malaria, behind. It was found out later that Francis Bailey had paid a Honduran gunboat captain to

assist in his escape. Bailey escaped to a nearby port and booked passage out of Honduras.

When the ship finally arrived in New York, Albert was tried and sentenced to four years in Sing Sing Prison in New York, where he died tragically, possibly as a complication of malaria. Captain Oxley was the star witness at the trial and was released. However, Francis Bailey, the mastermind of the Honduran pirate adventure, disappeared and could not be found.

Francis Bailey, fearing arrest in the United States, slipped into western Canada and settled in Whonnock, near the city of Vancouver. He cleared and irrigated a tract of land and set up a prosperous ranch. He changed his name to Colonel Edward Shannon Kirkconnel and posed as a Canadian land baron. Francis listed the owner of the ranch as a Katherine Maude Slocum, a New York City schoolteacher and friend. Francis was eventually caught after several of his letters to Slocum were intercepted by New York City police detectives and traced back to

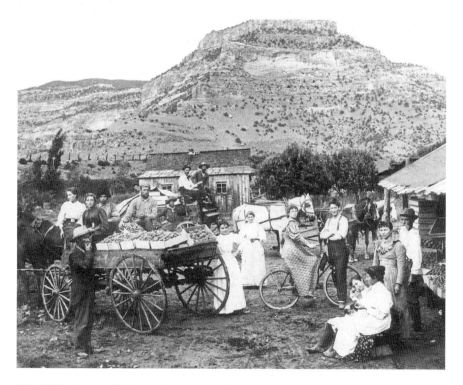

This 1896 photograph shows a large group of people packing apples at the Crawford ranch. *Museums of Western Colorado.*

The Crawford ranch as it looks today. *Museums of Western Colorado.*

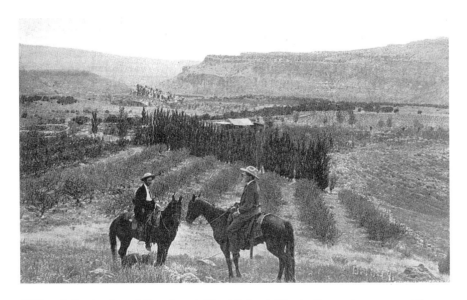

William Bailey, brother of Francis and Albert Bailey, talking to the ranch manager at the Crawford/Bailey ranch in 1905. The ranch house can be seen the background. *Museums of Western Colorado.*

The Crawford/Bailey ranch as it looks today. There is no trace of the once-productive 283-acre ranch or ranch house except for small sections of stacked-stone fence. *Museums of Western Colorado.*

Canada. Bailey was extradited, convicted of theft of the manufacturers' merchandise and sentenced to four years in Sing Sing Prison, ending the exploits of these twentieth-century cowboy/pirate adventurers. David Bailey had no luck finding any information about the Bailey brothers' ownership of the ranch house, only hundreds of documents regarding their legal troubles.

Bailey's research indicated the ranch was sold to several owners and eventually became a cattle ranch. The ranch and ranch house eventually disappeared after the water rights were sold, and the property was abandoned and returned to its natural appearance of sparse plants and high desert.

Bailey was looking at the early ranch pictures when he suddenly realized the location of George Crawford's ranch house was right in front of him. Bailey returned to the ranch site; aligned the 1896 and 1905 photographs with the mountains, hills and natural features in the background; and took photographs from the approximate location used by the nineteenth-century photographers. He could see the ranch house in the 1905 picture, and by aligning mountains and land features with the old photographs, he located

The WIT crew discovered fragments of 1880s fine china and an 1884 Rogers Brothers silver spoon at the site of George Crawford's house and packing shed. *Museums of Western Colorado.*

the original building site. On August 2, 2008, the WIT crew explored the area where George Crawford's ranch house was located before the turn of the century. The search group was composed of Museums of Western Colorado director Mike Perry, WIT director David Bailey, WIT scientific coordinator Rick Dujay, WIT archaeologist John Lindstrom, museum archeology volunteer Beverly Kolkman and WIT intern Jennifer Swedin. The team located broken china, a Victorian-era spoon and other nineteenth-century artifacts at the site of Crawford's ranch house and packing shed. Two artifacts dated to George Crawford's time, a fine china fragment that had a maker mark from the 1880s and a silver-plated spoon manufactured by the Rogers Brothers and dated to 1884. George A. Crawford's missing ranch house location was found and proved a great historical present for Mesa County's 125th anniversary celebration.

THE JENSEN TABLET

Stirling's Archaeological Forgeries

In 2008, Kannah Creek resident Vic Jensen told David Bailey and Rick Dujay that he had found a strange group of artifacts and pottery, including a tablet with a Mayan face and mysterious glyphs. In 1956, Vic Jensen and his family were on a summer hike in the Cactus Park, Colorado area. They came across a huge trove of strange-looking artifacts. Scattered beneath a small cliff were over one hundred arrowheads, pottery, a fire-starting kit and a Mayan-style tablet with strange glyphs carved in a serpentine design.

Jensen turned the unusual tablet and artifacts over to the Western Investigations Team hoping to solve the mystery. The top of the tablet had extremely detailed workmanship and featured a side profile of a Mayan nobleman, and the rest of the tablet had carefully incised glyphs. However, the strangely fired pottery had the appearance of a modern creation. The WIT crew studied the artifacts and concluded that the glyphs, designs and shapes used to make the tablet, pottery and other objects combined symbols from ancient civilizations from all over the world, and the objects were obviously forgeries.

In September 2009, the WIT crew's research on the Jensen tablet appeared in a *Grand Junction Daily Sentinel* article by Gary Harmon, "Is Stone Tablet from 1340 or 1940, Expert Asks." The article was an attempt to find out who created these artifacts and for what reason. It was discovered that master archaeology hoaxer Jack Daniels Stirling created this Mayan-inspired masterpiece. After reading the article, Sterling's daughter Julia and granddaughter Eleanor Vernon came forward with news that the Jensen

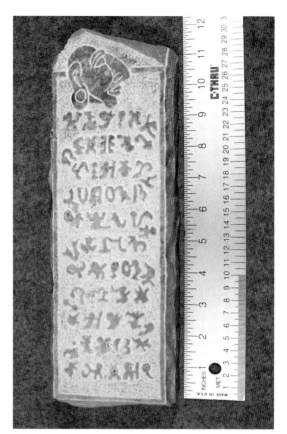

Right: The Jensen tablet, discovered by Vic Jensen in1956. *Museums of Western Colorado.*

Below: The strange pottery found by the Jensen family near Cactus Park, Colorado, in 1956. *Museums of Western Colorado.*

artifacts were fakes and explained the original scheme. The "Mayan" tablet was made by J.D. Stirling in the 1950s using Easter Island Rongo-Rongo script with Aztec and Mayan symbols thrown in for good measure. Stirling hoped his "archaeologic treasures" would be found in the nearby desert and make archaeologists believe they had found an unknown civilization. During the 1950s, western Colorado was full of archaeologists making new discoveries that were reported nearly every week in the *Daily Sentinel*. Stirling, who was a stone-carver, flintknapper and potter, decided to use his skills to create his own "lost" civilization. His goal was to fool well-known amateur archaeologist Al Look, who was usually at the center of the latest archaeological finds. He hid four caches from his lost civilization in the Cactus Park area, south of Grand Junction, Colorado. In 1954, local cowboy O.E. "Roxy" Chambers found the first cache, and it was reported in the paper as an "an archaeological jackpot." No other caches were reported, and Stirling passed away, never revealing his secret hoax on area archaeologists.

In June 2014, *Daily Sentinel* photographer Christopher Tomlinson located unusual carved stone effigies near Westwater, Utah, and showed the pictures to David Bailey. Bailey found the original 1954 article of the O.E. Chambers discovery in the Loyd Files Research Library at the Museum of the West (a division of the Museums of Western Colorado). The newspaper photographs of the strange carved stone head found by the local cowboy looked almost identical to the Westwater, Utah carvings. The *Daily Sentinel* ran the story about the discovery of another Stirling forgery in Utah. Jack Daniels Stirling's "lost civilization" was still mystifying desert hikers and travelers some fifty years after his hoax on early archaeologists.

SELECTED BIBLIOGRAPHY

Mesoamerican History

Bierhorst, John. *History and Mythology of the Aztecs: The Codex Chimalpopoca*. Tucson: University of Arizona Press, 1992.

Boone, Elizabeth Hill. *The Aztec World*. Montreal: St. Remy Press, 1994.

Boone, Elizabeth Hill, and Walter D. Mignolo, eds. *Writing Without Words: Alternate Literacies in Mesoamerican and the Andes*. Durham and London: Duke University Press, 1994.

Carrasco, Davíd. *Quetzalcoatl and the Irony of Empire: Myths and Prophecies in the Aztec Tradition*. 2nd ed. Boulder: University of Colorado Press, 2000.

———. *Religions of Mesoamerica: Cosmovision and Ceremonial Centers*. San Francisco: Harper, 1990.

Carrasco, Davíd, ed. *Aztec Ceremonial Landscapes*. Boulder: University of Colorado Press, 1991.

Castañeda de Nájera, Pedro de. *Narrative of the Coronado Expedition*. Edited by John Miller Morris. Chicago: R.R. Donnelley, 2002.

Clavijero, Francisco Javier. *Historia Antigua De Mexico*. Mexico City: Editorial Porrua, 1971.

Clendinnen, Inga. *The Aztecs*. Cambridge: Cambridge University Press, 1991.

Coe, Michael D., and Rex Koontz. *Mexico: From the Olmecs to the Aztecs*. 5th ed. New York: Thames and Hudson, 2003.

Davies, Nigel. *The Toltec Heritage: From the Fall of Tula to the Rise of Tenochtitlán*. Norman: University of Oklahoma Press, 1980.

————. *The Toltecs: Until the Fall of Tula*. Norman: University of Oklahoma Press, 1977.

Durán, Fray Diego. *The Aztecs: The History of the Indies of New Spain*. Translated by Doris Heyden and Fernando Horcasitas. New York: Orion Press, 1964.

Garcia Payón, José. *Malinalco: Official Guide*. Mexico: Instituto Nacional de Antropologia e Historia, 1958.

Gillmor, Frances. *The King Who Danced in the Marketplace*. Tucson: University of Arizona Press, 1964.

Lekson, Stephen H. *The Chaco Meridian: Centers of Political Power in the Ancient Southwest*. Walnut Creek, CA: AltaMira Press, 1999.

Miller, Mary, and Karl Taube. *The Gods and Symbols of Ancient Mexico and the Maya: An Illustrated Dictionary of Mesoamerican Religion*. New York: Thames and Hudson, 1993.

Mundy, Barbara E. *The Mapping of New Spain: Indigenous Cartography and the Maps of the Relaciones Geográficas*. Chicago: University of Chicago Press, 1996.

Townsend, Richard F. *The Aztecs*. 2nd ed. New York: Thames and Hudson, 2000.

Vaillant, George C. *Aztecs of Mexico*. Garden City, NJ: Doubleday, 1950.

Spanish Colonial History and Cartography

Allan, Philip. *The Atlas of Atlases*. London: Quantum Books, 1992.

Auerbach, Herbert S. "Father Escalante's Journal 1776–77, Newly Translated with Related Documents and Original Maps." *Utah Historical Quarterly* 11, no. 4 (1943).

Benavides, Fray Alonso de. *The Memorial of Fray Alonso de Benavides*. Translated by Mrs. Edward E. Ayer. Albuquerque: Horn and Wallace Publishers, 1965.

Bolton, Hubert Eugene, ed. *Spanish Exploration in the Southwest: 1542–1706*. 3rd ed. New York: Barnes and Noble Books, 1976.

Cleven, N. Andrew N. *Readings in Hispanic American History*. Boston: Ginn and Company, 1927.

Clissold, Stephen. *The Seven Cities of Cíbola*. London: Shenval Press, 1961.

Cortés, Hernán. *Hernán Cortés: Letters from Mexico*. Translated and edited by A.R. Pagden. New York: Grossman Publishers, 1971.

Daniels, George C., ed. *The Spanish West*. New York: Time Inc., 1976.

Domínguez, Fray Francisco Atanasio. *The Missions of New Mexico: A Description by Fray Francisco Atanasio Dominquez with other Documents*. Translated by

Eleanor B. Adams and Fray Angelico Chavez. 2nd ed. Albuquerque: University of New Mexico Press, 1975.

Hakluyt, Richard. *Divers Voyages Touching on the Discouerie of America 1582.* 6th ed. Fairfield, WA: Ye Galleon Press, 1981.

————. *Voyages and Documents.* London: Oxford Press, 1963.

Johnson, Donald S. *Phantom Islands of the Atlantic.* 2nd ed. London: Souvenir Press, 1997.

Lavender, David. *De Soto, Coronado, Cabrillo: Explorers of the Northern Mystery.* Washington, D.C.: National Park Service, Division of Publications, 1992.

Lavin, James D. *A History of Spanish Firearms.* London: Herbert Jenkins, 1965.

López de Gómara, Francisco. *Cortés: The Life of the Conqueror by His Secretary.* Translated and edited by Lesley Bird Simpson. Berkeley and Los Angeles: University of California Press, 1965.

Lovelace, Maud Hart. *What Cabrillo Found.* New York: Thomas Y. Crowell Company, 1958.

MacNutt, Francis Augustus, trans. and ed. *Fernado Cortés: His Five Letters of Relation to the Emperor Charles V 1519–1526.* 2nd ed. Glorieta, NM: Rio Grande Press, 1977.

Masefield, John. *On the Spanish Main.* 2nd ed. London: Conway Maritime Press, 1972.

Mathes, W. Michael, trans. and ed. *The Conquistador in California 1535: The Voyage of Fernando Cortés to Baja California in Chronicles and Documents.* Los Angeles: Dawson's Book Shop, 1973.

Nauman, James D., ed. *An Account of the Voyage of Juan Rodríguez Cabrillo.* San Diego: Cabrillo National Monument Foundation, 1999.

O'Crouley, Pedro Alonso. *A Description of the Kingdom of New Spain 1774.* Translated and edited by Seán Galvin. San Francisco: John Howell Books, 1972.

Pino, Don Pedro Bautista, Antonio Barreiro and Don José Agustín de Escudero. *Three New Mexico Chronicles: The Exposición of Don Pedro Bautista Pino 1812; the Ojeada of Lic. Antonio Barreiro 1832; and the additions by Don José Agustín de Escudero, 1849.* Translated by H. Bailey Carroll and J. Villasana Haggard. 2nd ed. New York: Arno Press, 1967.

Polk, Dora Beale. *The Island of California: A History of the Myth.* Lincoln: University of Nebraska Press, 1991.

Posada, Alonso de. *Alonso de Posada Report, 1686: A Description of the Area of the Present Southwestern United States in the Late Seventeenth Century.* Translated and edited by Alfred Barnaby. Vol. 4. Pensacola: Perdido Bay Press, 1982.

Ramsey, Raymond H. *No Longer on the Map: Discovering Places that Never Were.* New York: Ballantine Books, 1973.

Reyher, Ken. *Wilderness Wanderers.* Montrose, CO: Western Reflections, 2003.

Sanchez, Joseph P. *Explorers, Traders, and Slavers: Forging the Old Spanish Trail 1678–1850.* Salt Lake City: University of Utah Press, 1997.

Sauer, Carl O. *The Road to Cibola.* Berkeley: University of California Press, 1932.

————. *Seventeenth Century North America.* Berkeley: Turtle Island, 1980.

Secoy, Frank Raymond. *Changing Military Patterns of the Great Plains Indians.* Lincoln: University of Nebraska Press, 1992.

Simmons, Marc, and Frank Turley. *Southwestern Colonial Ironwork: The Spanish Blacksmithing Tradition from Texas to California.* Santa Fe: Museum of New Mexico Press, 1980.

Thomas, Alfred Barnaby, trans. and ed. *Forgotten Frontiers: A Study of the Spanish Indian Policy of Don Juan Bautista de Anza Governor of New Mexico 1777–1778.* 2nd ed. Norman: University of Oklahoma Press, 1969.

Wilford, John Noble. *The Mapmakers: The Story of the Great Pioneers in Cartography from Antiquity to the Space Age.* New York: Vintage Books, 1982.

Wood, Michael. *Conquistadors.* Berkeley and Los Angeles: University of California Press, 2000.

Ute History, Myth and Legends

Conetah, Fred A. *A History of the Northern Ute People.* Salt Lake City: Uintah-Ouray Ute Tribe, 1982.

Dixon, Madoline C. *These Were the Utes.* Provo: Press Publishing, 1983.

Emmitt, Robert. *The Last War Trail: The Utes and the Settlement of Colorado.* 2nd ed. Norman: University of Oklahoma Press, 1972.

Mason, J. Alden, Katherine Jenks, Daisy Jenks, Marietta Reed, Norma Denver, June Lyman, Floyd A. O'Neil, Gregory C. Thompson and Fred Conetah. *Weenoocheeyoo Peesaduehnee Yak:anup: Stories of Our Ancestors.* Salt Lake City: Uintah-Ouray Ute Tribe, 1974.

Smith, Anne M., ed. *Ute Tales.* Salt Lake City: University of Utah Press, 1992.

Zingg, Robert M. *The Ute Indians in Historical Relation to Proto-Azteco-Tanoan Culture.* Denver: University of Denver, 1938.

vWeapons and Weaponry

Lavin, James D. *A History of Spanish Firearms*. London: Herbert Jenkins, 1965.
Peterson, Harold L. *Arms and Armor in Colonial America: 1526–1783*. New York: Bramhall House, 1956.
———. *Daggers & Fighting Knives of the Western World: From the Stone Age till 1900*. New York: Bonanza Books, 1968.
Pohl, John, M.D., and Angus McBride. *Aztec, Mixtec, and Zapotec Armies*. 7th ed. Oxford: Osprey Publishing, 1999.
Russell, Carl P. *Firearms, Traps, & Tools of the Mountain Men*. Albuquerque: University of New Mexico Press, 1967.

Western Colorado History

Gantt, Paul H. *The Case of Alfred Packer, the Man Eater*. Denver: Denver University Press, 1952.
Hill, Alice Polk. *Tales of the Colorado Pioneers*. 2nd ed. Glorieta, NM: Rio Grande Press, 1976.
Jocknick, Sidney. *Early Days on the Western Slope*. 2nd ed. Ouray, CO: Western Reflections, 1998.
Kushner, Ervan F. *Alferd G. Packer: Cannibal! Victim?* Frederick, CO: Platte' N Press, 1980.
Marshall, Muriel. *Grand Mesa: Island in the Sky*. 2nd ed. Montrose, CO: Western Reflections, 2005.
Mazzulla, Fred, and Jo Mazzulla. *Al Packer, a Colorado Cannibal*. Denver, 1969.
Noel, Thomas J. *The WPA Guide to 1930s Colorado*. Lawrence: University Press of Kansas, 1987.

Articles and Journals

Arrington, Keith. "Highest Hills or Lowest Vales." Phoenix Masonry. Last modified 2013. http://phoenixmasonry.org/highest_hills_or_lowest_vales.htm.
Pollock, John W., Michael Barnes and Jonathan Ferguson. 1997 Archaeological Excavations La Vase Heritage Project, City of North Bay, Canada. Last modified 1998. www.city.north-bay.on.ca/lavase/index.htm.

Southern Colorado Register. "Did Colorado's First Explorers Lose Bronze Relic?" September 1, 1961.

Vallancey, Charles, Thomas Pownall, Edward Ledwich, James Ussher, Sir Henry Piers, Charles O'Connor, Esq., W. Beauford and Sir J. Davis. "A Vindication of the Ancient History of Ireland." *Collectanea de Rebus Hibernicus* 14, no. 2 (1786): xvii.

Wilcox, David R., Phil C. Wiegand, J. Scott Wood and Jerry B. Howard. "Ancient Cultural Interplay of the American Southwest in the Mexican Northwest." *Journal of the Southwest* 50, no. 2 (2008): 103–206.

INDEX

Vélez de Escalante, Fray Francisco
 Silvestre 28, 30, 31, 60, 61, 69,
 70, 71, 74
Vernal, Utah 92
Vision of Constantine 26, 29
Vizcaíno, Sebastián 57, 58

W

Walters Art Museum 51
wedding baskets 81
Western State College 14, 15
Western State College Museum 15
western tanager 92
Westways magazine 65
wheellock 44, 47, 48, 49, 50, 51, 52
white limestone plumes 85
White River Museum 75
Whitewater Basin 85, 95, 96, 97
Wilcox, David 94
Wilkinson, Cecil 51
Williams, Chad 18, 20, 21
Wood, W.W. 64
Wubben Science Center 44

Z

Zárate Salmerón, Fray Gerónimo 78
Zuñi 31, 60

ABOUT THE AUTHOR

David Bailey has been the curator of history at the Museum of the West (a division of the Museums of Western Colorado) for twenty-six years. He enjoys researching western Colorado history, historic preservation, public history and museum exhibition design. Bailey has also served as a documentary film presenter and consultant, working with National Geographic, the History Channel, the Travel Channel and the BBC. In 2005, Bailey became director of the Western Investigations Team, a historical and scientific research group that investigates western Colorado historical mysteries. He and his wife, Debbie, live in Grand Junction, Colorado.

Visit us at
www.historypress.com